WORLD FILM LOCATIONS
HAVANA

Edited by Ann Marie Stock

First Published in the UK in 2014 by Intellect Books, The Mill, Parnall Road, Fishponds, Bristol, BS16 3JG, UK

First Published in the USA in 2014 by Intellect Books, The University of Chicago Press, 1427 E. 60th Street, Chicago, IL 60637, USA

Copyright ©2014 Intellect Ltd

Cover photo: *Chico & Rita* (2010) Isle of Man Film/Estudio Mariscal/ Fernando Trueba Producciones Cin-ematográficas/ The Kobal Collection

Copy Editor: Emma Rhys

Typesetting: Jo Amner

A Catalogue record for this book is available from the British Library

World Film Locations Series
ISSN: 2045-9009
eISSN: 2045-9017

World Film Locations Havana
ISBN: 978-1-78320-197-6
ePDF ISBN: 978-1-78320-253-9
ePub ISBN: 978-1-78320-254-6

Printed and bound by Bell & Bain Limited, Glasgow

WORLD FILM LOCATIONS HAVANA

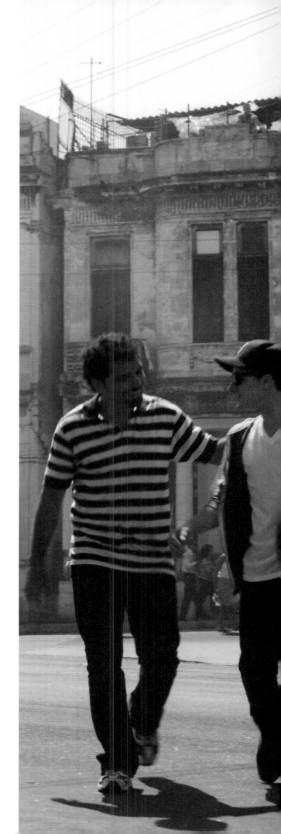

EDITOR
Ann Marie Stock

SERIES EDITOR & DESIGN
Gabriel Solomons

CONTRIBUTORS
Guy Baron
M. Troy Davis
Désirée Díaz
Pablo Fornet
Miryorly García Prieto
Kathy Hornsby
Susan Lord
Mario Naito López
Antonio A. Pitaluga
Laura Podalsky
Richard Reitsma
Emma Rodvien
Ann Marie Stock
Rob Stone
Fabienne Viala
Carl Wilson

LOCATION PHOTOGRAPHY
M. Troy Davis
Kathy Hornsby
Emma Rodvien
Ann Marie Stock
(unless otherwise credited)

LOCATION MAPS
Greg Orrom Swan

PUBLISHED BY
Intellect
The Mill, Parnall Road,
Fishponds, Bristol, BS16 3JG, UK
T: +44 (0) 117 9589910
F: +44 (0) 117 9589911
E: *info@intellectbooks.com*

Bookends: Ann Marie Stock
This page: *7 Days in Havana* (Kobal)
Overleaf: *Buena Vista Social Club* (Kobal)

CONTENTS

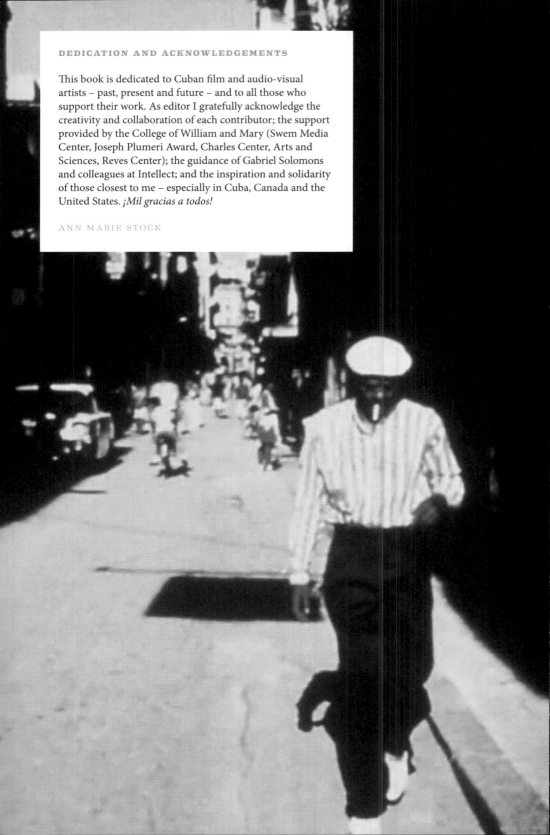

DEDICATION AND ACKNOWLEDGEMENTS

This book is dedicated to Cuban film and audio-visual artists – past, present and future – and to all those who support their work. As editor I gratefully acknowledge the creativity and collaboration of each contributor; the support provided by the College of William and Mary (Swem Media Center, Joseph Plumeri Award, Charles Center, Arts and Sciences, Reves Center); the guidance of Gabriel Solomons and colleagues at Intellect; and the inspiration and solidarity of those closest to me – especially in Cuba, Canada and the United States. *¡Mil gracias a todos!*

ANN MARIE STOCK

INTRODUCTION

World Film Locations Havana

EDUARDO GALEANO CAPTURES the sentiment of many a film aficionado in commenting on the miraculous nature of cinema. He tells us that whereas cinnamon helps relieve the symptoms of a chest cold, and parsley can ward off the effects of rheumatism, it is the cinema that cures everything else. More than a century after the first moving pictures made their way to Cuba's shores in 1897 and shortly thereafter began to be filmed on the island, movies are still miraculous in Cuba.

This volume is designed to share with you a sampling of the many ways Havana has been captured and constructed for the screen. While no single text can treat all the films that cast Havana as protagonist, in these pages you will find quite a variety: genres spanning from A to Z, from animated features to a zombie movie; and works from three different centuries, beginning as early as 1898 and extending into present times. Most of these were filmed in Cuba, but some came to life on soundstages located elsewhere. You will glimpse iconic locales like Sloppy Joe's Bar and the Tropicana, the Capitolio and Revolution Square, and will also discover less familiar urban spaces including various rooftops across the city, non-descript household interiors, and a *paladar* family restaurant.

The series of Spotlight essays will take you on a tour of the city's movie theatres over the past century, track the mythmaking of directors approaching Havana from distant shores, and flash back to the 1960s when a revolutionary cinema was envisioned and established. Along the way, you will be introduced to monuments and cultural icons that have figured in constructing the City's allure, the island's vibrant film festivals and filmgoing culture, and a new generation of 'Street Film-makers' who are as entrepreneurial as their work is innovative.

As you read the 44 film scenes reviewed, and peruse the several hundred screen shots, you will likely recall seeing some of the films. And you may be enticed to watch others. And as you take in the present-day location photos and explore the coordinates of 'cinema' and 'Cuba' through the Spotlight essays, you may long to see Havana for yourself.

The volume brings together a cadre of contributors with diverse voices and visions. Hailing from a half-dozen countries, some have lived their entire lives in Cuba's capital, or have left only recently to follow their dreams in different directions; others have arrived on the island after travelling long distances with foreign passports and tourist visas or press passes. They are specialists in fields as diverse as geography and photography, media literacy and pedagogy, history and cultural studies, and cinema. Despite their differences, something unites these writers and photographers; they share a passion for film, and a love – yes love – for Havana and *Habaneros*. Together we extend an invitation to you ... please join us in experiencing this montage of imaginings; together we will marvel at this soulful city and its soul-filled inhabitants. ✤

Ann Marie Stock, Editor

HAVANA

City of the Imagination

Text by
ANN MARIE
STOCK

Where would I be without you, my city of Havana?
My city of light and spray ...'

(Fayad Jamis)

IN HIS LOVE POEM devoted to La Habana, Fayad Jamis shares his admiration of this attractive city, with her curving arches and winding walkways. The Cuban poet lingers on her columns, her kisses, her windows. Wooing the object of his devotion, 'my woman forever,' he is warmed by her light, enveloped in her misty sea spray. 'If you did not exist,' he confesses, 'I would invent you my city of Havana.'

And indeed, Havana has been invented time and time again – in poems and posters, maps and musical scores, drawings and paintings, photographs and films. Through the ages these texts and sounds and images have captured the charm – *el encanto* – of this Caribbean capital. Since the invention of moving pictures, film-makers have depicted the City's parks and promenades, buildings and *barrios*, monuments

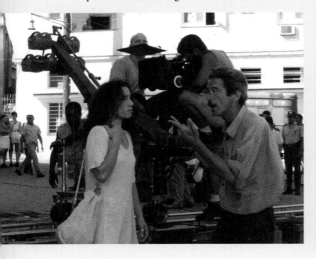

and the meandering Malecón. Perhaps more than any other rendering, it is through the lenses of these film-makers, that we have come to envision this 'window to the sea' (Jesús Orta Ruiz).

Havana is a city imagined in pastel hues – tan linen suits and taupe straw hats and a rainbow of *guayabera* shirts, gray marble and cement-tone structures, minty-green *mojitos* and pale-pink *daiquiris*. And always the aquamarine of the sea and sky, those 'fathomless blues,' Jamis poignantly notes, that 'saturate' our 'visual memory'. Sometimes these soft shades recreate the aura of an era as they do in *Hello Hemingway* (Fernando Pérez, 1990) and *La Edad de la peseta/The Awkward Age* (Pavel Giroud, 2006). Other times they reflect fading and deterioration from harsh sunlight and neglect as in and *Life is to Whistle* (Fernando Pérez, 1998) and *Unfinished Spaces* (Alysa Nahmias and Benjamin Murray, 2011). Always, though, these sun-washed colors are associated – evocatively and unmistakably – with this urban space.

Havana is a city imagined in vibrant rhythms. Ruffled dancers whirling under fruit-heavy headdresses on the Tropicana stage as in *Weekend in Havana* (Walter Lang, 1941) and *Chico & Rita* (Fernando Trueba, Tono Errando and Javier Mariscal, 2010); bongos and congas and maracas marking the beat to move the musicians as in *Buena Vista Social Club* (Wim Wenders, 1998); and sassy trumpets collide in brassy exuberance as in *Vampiros en La Habana/Vampires in Havana* (Juan Padrón, 1985); *PM* (Sabá Cabrera Infante and Orlando Jiménez Leal, 1961) proffers a late-night riff of the city's darker side, a face of Havana not seen by all. As more recent works attest – *Suite Habana/Havana Suite* (Fernando Pérez, 2003), *Habana Blues/Havana Blues* (Benito Zambrano, 2005), *Oda a la Piña/Ode to the Pineapple* (Laimir Fano, 2008), *Revolución/Revolution* (Mayckell

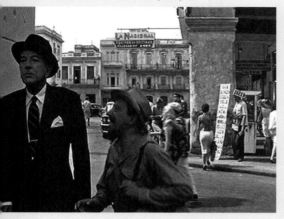

Above © 1959 Kingsmead Productions
Opposite © Cuban Film Institute/ICAIC

Pedrero Mariol, 2010) – Cuba's capital remains replete with sounds.

Havana is a city imagined in terms of action. Early films proffer roller coaster riding (*Parque de Palatino/Palatino Park* [Enrique Díaz Quesada, 1898]), romancing (*Romance del Palmar/It Happened in Havana* [Ramón Peón, 1938]), dancing (*Havana Widows* [Ray Enright, 1933]), and spying (*Our Man in Havana* [Carol Reed, 1959]). By the 1960s, the National Film Institute (ICAIC) is generating a successful body of work celebrating the Revolution, and reflecting on the impact of the pervasive changes: *Cuba Baila/ Cuba Dances* (Julio García Espinosa, 1960), *Yo Soy Cuba/I Am Cuba* (Mikhail Kalatozov, 1964) (co-produced with the USSR), *La Muerte de un burócrata/Death of a Bureaucrat* (Tomás Gutiérrez Alea, 1966), *Memorias del subdesarrollo/ Memories of Underdevelopment* (Tomás Gutiérrez Alea, 1968), and so many others. More recently, audio-visual art made within Cuba reveals struggling, adapting, *resolviendo* or making do as in the case of numerous documentaries and experimental shorts as well as features including *La Piscina/ The Swimming Pool* (Carlos Quintela, 2011), *La Película de Ana/Ana's Movie* (Daniel Díaz Torres, 2012), and *La Pared de las Palabras/ Wall of Words* (Fernando Pérez, 2014).

Havana is a city imagined in pastel hues – tan linen suits and taupe straw hats and a rainbow of *guayabera* shirts, gray marble and cement-tone structures, minty-green *mojitos* and pale-pink *daiquiris*.

Havana is a city imagined through comings and goings. Aeroplanes land and take off; ships dock and leave port; helicopters whir down and hot-air balloons float upward. And there are the rafts, those makeshift crafts on which *balseros* floated away from the island during the height – or depths – of the Special Period crisis. The emotions provoked by encounters and separations are evident in such films as *Reina y Rey/Queen and King* (Julio García Espinosa, 1994), *Miel para Oshun/Honey for Oshun* (Humberto Solás, 2001), *Viva Cuba* (Juan Carlos Cremata, 2005), *Larga distancia/Long Distance* (Esteban Insausti, 2010), and *La Mirada/The Gaze* (Alfredo Ureta, 2011). Through these and other representations, spectators share in the anticipation of arrival and the anguish of departure.

Havana is a city imagined through open horizons and closed interiors. Filmgoers gaze upon the Vedado district from atop the Hotel Capri in *The Godfather: Part II* (Francis Ford Coppola, 1974) and the zombie-killers' *azotea* perch in *Juan de los muertos/Juan of the Dead* (Alejandro Brugués, 2011); against the backdrop of Old Havana Ana tells her story in *Ana's Movie*; and Larita seeks to connect and communicate by aligning herself with the rooftop antennae in *Madagascar* (Fernando Pérez, 1994). These panoramic perspectives of the city contrast with domestic interiors – Daniel confining himself to the few rooms of his sparsely furnished dwelling in *La Guarida del Topo/The Mole's Hideout* (2011); Diego creating the sanctuary not available to him outside his home in *Fresa y chocolate/Strawberry and Chocolate* (Tomás Gutiérrez Alea and Juan Carlos Tabío, 1993); the Reinaldo Arenas figure taking refuge in the home of Lezama Lima in *Antes que anochezca/Before Night Falls* (Julian Schnabel, 2001); and Lino contemplating photographs in his bedroom in *Esther Somewhere/Esther en alguna parte* (Gerardo Chijona, 2012). Urban spaces are selected, created and depicted to evoke expansiveness as well as claustrophobia.

As the 'face' of the city has changed – architecturally, demographically, culturally – so have its on-screen representations. Despite these different depictions over time, the films featured herein, like the city itself, leave us feeling as Jamis did. When we 'wander the world', Havana holds us spellbound. And when we leave the cinema after the final credits roll (or power down our laptop), the images of lovely Havana linger – like 'a song in our throat'. ✤

MONUMENTAL HAVANA

Text by
DÉSIRÉE
DÍAZ

ONE OF THE DISTINCTIVE QUALITIES of Cuban cinema has been the glorification of Havana and the consolidation of the city as a cultural and urban myth. Interestingly, cinematic representations of memorial squares and sculptures have been mostly contentious. Whereas the aerial shots of the city's skyline and the Malecón shoreline, as well as the close takes of people walking and talking around the city, have expressed the intrinsic strength and everyday vitality of Havana – even in those gruelling images of the cyclists in *Madagascar* (Fernando Pérez, 1994) – the images of emblematic obelisks, commemorative columns and effigies of Cuba's capital have emphasized the city as a space of resistance and as an allegory of the conflicts and failures of the Revolution's ideological discourse. With scathing irony, Cuban cinema has incisively questioned

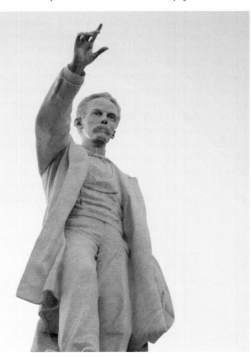

power through the rhetorical use of memorial sites and the attempts to rewrite history through the re-semantization of architecture and urbanism.

As early as in 1966 in *Muerte de un burócrata/ Death of a Bureaucrat*, Tomás Gutiérrez Alea satirized the process of planting nationalist remembrances in the urban setting. The film opens with the funeral of one of the characters; obsessed with the massive production of busts of José Martí, he dies trying to reach the goal of 'giving every Cuban family the possibility of having a patriotic altar at home'. The countless multiplication of Martí's torsos critiques the didactic and paternalistic way of reinforcing the historical and political narratives implicit in the ubiquitous reproduction of the National Hero. *Death of a Bureaucrat* contrasts the proletarian ideal and the reminiscences of the socialist-realism style of the busts with the cemetery, a landscape replete with the sculptures of angels and cherubs favoured by the bourgeoisie. The parodic visual anaphora comments on the ideological contradictions between the past and the present revealed in the urban text.

A couple of years later, in *Memorias del subdesarrollo/Memories of Underdevelopment* (1968), Alea addresses the use of statuary and tributary monuments as places of political and ideological negotiations between the republican past, the revolutionary present, and an unknown future. In fact, the entire film can be understood as a meditation on the Revolution's attempts to overwrite the city, a meditation that exposes the strategies of the ideological reconfiguration of the urban space as well as the conflicts this process provokes. Sergio persistently questions the urban signs that the Revolution has tried to reformulate semantically to convey the new discourses. His telescopic lens focuses on a landmark, a monument formerly crowned by an imperial eagle, then dethroned in order to be topped by a dove promised by Pablo Picasso. That the Spanish artist's bird never arrived means that during the film-maker's time, as today, the monument

Opposite Statue of Juan Marti
Below *Death of a Bureaucrat* (1966)

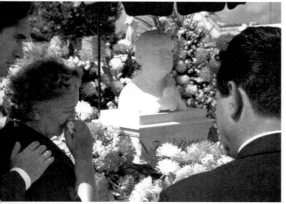

Above © 1966 ICAIC
Opposite © Ann Marie Stock

consists of a pair of headless pillars.

Whereas Cuban cinema in the 1960s questioned the capacity of the revolutionary project to update and adapt urban symbols in accordance with new values, in the late twentieth and early twenty-first centuries another cycle of contestation takes place: it is based on the urban markers sanctioned by revolutionary power. Sergio's caustic view in *Memories* is recaptured in more recent films, but with an additional function – it works to legitimate the voice of the Other that reclaims changes.

The independent documentary *Calle G/G Street* (Aram Vidal and Erick Coll, 2003) portrays the phenomenon of Havana's urban tribes and their particular relationship with the space. In contrast to other subcultures in the global context, which tend to reproduce their marginal position withdrawing geographically and asserting their identity from the periphery, Havana's tribes get together on the centrally located Avenue of the Presidents; this route, as its name suggests, is devoted to the remembrance of illustrious individuals. *G Street* emphasizes the contrast between the traditional severity of the statues of Latin American presidents, and the hoards of punks, rappers and emos that occupy the park at Calle G every night. Furthermore, by suggesting a semantic transference between both elements and the use of intertextual references, the film

With scathing irony, Cuban cinema has incisively questioned power through the rhetorical use of memorial sites and the attempts to rewrite history through the re-semantization of architecture and urbanism.

renews and re-contextualizes the official thought in order to validate the tribes' alternative practices. For example, a low-angle shot of the statue of Benito Juárez gives way to a close-up of the Mexican hero's bronzed finger pointing down. Thus, the editing can be read as an order issued by History to pay attention to the 'low', to the 'inferior'; the gesture is adopted immediately by the camera, lowering the focus and sitting down on the floor to talk directly with the young members of the tribes. Juarez's famous quote underscores the message: 'respect for the right of others is peace.' Through this metalepsis, in which a reference is used in a new context, the documentary seeks to authorize the emergent discourses and practices by means of the very same ideals proclaimed by the power; its ironic tone desecrates the hegemonic representations.

The same procedure is articulated, although with more drama, in the closing scene of *Life is to Whistle* (Fernando Pérez, 1998). It takes place in the historical Revolution Square. In opposition to crowds of faceless masses gathered under the single voice of Fidel Castro – an image that for decades served to illustrate popular support for the revolutionary process – the Square in Perez's film – empty, dark and gloomy – shelters only three dissimilar characters resolved to chant their own song in order to defend difference and plurality.

The discourses related to the iconic Revolution Square are interrogated once again in the iconoclastic *Juan de los muertos/Juan of the Dead* (Alejandro Brugués, 2011). Below the gigantic relief of Ernesto 'Ché' Guevara, along with his proverbial phrase of 'Toward victory always', Juan fights against a mob of Cuban zombies, destructively alive after death. In ideological and political terms, the scene is further complicated when, at least this time around, the Cuban hero is saved by an American Yankee who, with colonizing attitude and English speech, is able to control and take possession of the besieged city. This sequence in particular, and the entire film, challenge notions of victory, life and death for the homeland; these concepts are associated with this political space as well as with the foundational rhetoric of the Cuban nation from the time of the independence wars. Allegorically, the city as a space of patriotic celebration, along with its monuments, statues and other urban icons and landmarks, remains destroyed, erased; as such it reclaims its condition of palimpsest, ready to be written anew. ✸

N

LOCATIONS MAP

HAVANA

maps are only to be taken as approximates

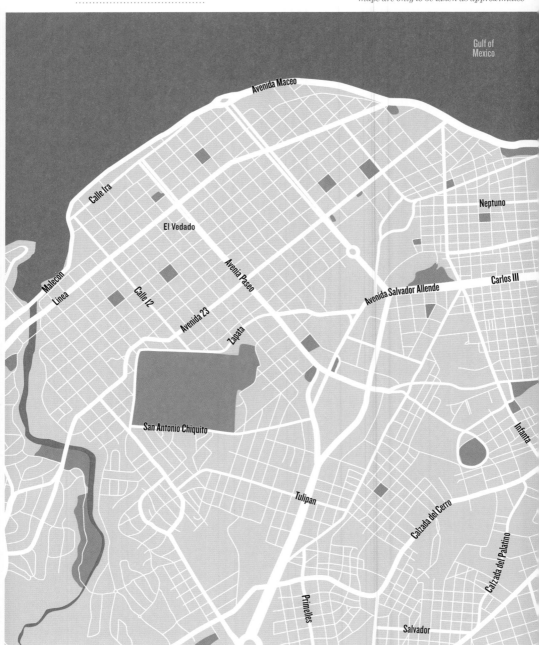

Gulf of Mexico

Avenida Maceo

Calle Ira

El Vedado

Neptuno

Avenia Paseo

Malecón

Linea

Calle 12

Avenida 23

Zapata

Avenida Salvador Allende

Carlos III

San Antonio Chiquito

Infama

Tulipan

Calzada del Cerro

Calzada del Palatino

Primelles

Salvador

HAVANA LOCATIONS
SCENES 1-5

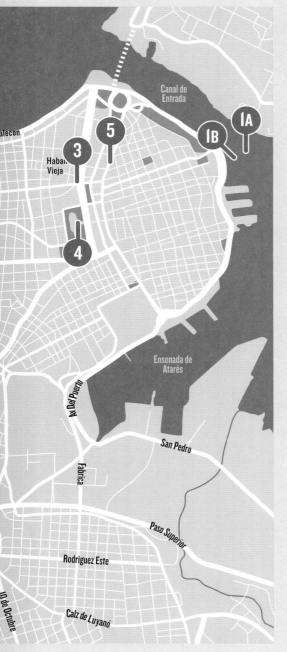

WRECK OF THE BATTLESHIP 'MAINE' AND MORRO CASTLE, HAVANA HARBOR (1898)

Havana Harbour and Morro Castle/Three Kings Fortress

DUE TO THE RISING commercial demand for dramatic content in the new medium of film, William Paley was commissioned in 1898 to record footage of the build-up to the Spanish–American War – the first major conflict to be captured on film. *Wreck of the Battleship 'Maine'* and *Morro Castle, Havana Harbor* present the viewer with shots tracking from right to left of their subjects, both taken from moving boats within the Harbour itself. The Morro Castle, built in 1589 while Cuba was under Spanish rule, looks imposing and impenetrable; contained barely within the frame of the shot, except where the lighthouse juts through the dominating horizontal fortifications. Morro was chosen possibly because of the stark contrast it presents to the partnered short, where the mangled remains of the hulking American *Maine* are isolated in potentially hostile waters with smaller craft circling it. War began within months of the footage being shot, but surrounded by a landscape of the Havana shores, where there is significantly more greenery and less industry than can be seen today, the Maine was an uncomfortable feature of the Harbour for another thirteen years, until 1911. *The New York Journal* (1898) provided a sensationalist 'yellow press' context when they reported that as 'Paley entered the harbor at Havana the pilot attempted to throw the photographic apparatus overboard [....] Spanish officers also boarded the yacht and attempted to arrest the photographer'. Through US media reportage, events surrounding the Maine's mysterious destruction became the public rallying point for war. Therefore, while Paley's two remaining Havana 'actualities' are an interesting visual record of nineteenth-century Havana, their historical context and purpose as entertainment is both complex and significant. **•◊Carl Wilson**

Photo © Kathy Hornsby

Directed by William Paley

Scene description: *Two short 'actuality' films, one showing a sunken ship in Havana Harbor and the second depicting the Morro Castle*

Timecode for scene: *0:00:00 – 0:00:49*

WRECK OF THE BATTLESHIP 'MAINE' MORRO CASTLE, HAVANA HARBOUR

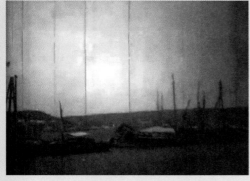 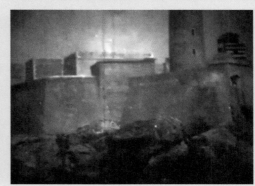

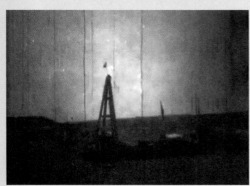 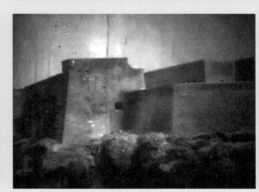

HAVANA WIDOWS (1933)

LOCATION *Warner Bros. Studios, Burbank, California*

HAVANA WIDOWS is a classic pre-code comedy 'sex film' from the Hollywood studio system, where the titillation of the story takes place in an 'other' foreign land, whilst the film itself is shot entirely on soundstages and back lots in California, United States. Joan Blondell and Glenda Farrell made eight films together in rapid succession. Starting with *Havana Widows*, they created their American 'working gal' caricatures as the eponymous gold-digging, burlesque dancers that stalk the luxurious hotel rooms and nightclubs of Havana, looking for rich American men to blackmail. Despite a generic set-design (circular tables arranged around a dance floor with an upper stage for the band) that scarcely attempts to emulate the architecture of Havana landmarks such as the Hotel Nacional de Cuba or El Floridita (though there is some 'exotic' foliage strewn about the place), the fictional Coffin Nail Café is where the fantasy of an upper-class 'Tropical Playground' is most keenly presented. The club is introduced through a Latino dance routine, although the ruffled taffeta number is performed by Hollywood-style peroxide-blonde chorus girls and is more in keeping with the Brazilian Samba craze that was sweeping America in the 1930s. In a five-minute sequence, Mae and Sadie (Blondell and Farrell) manage to swap the older rich man that they are entertaining for his suave, more attractive son. Encouraged by her success, Mae then shares a passionate moment with the stranger and they promise to meet again. This Havana is idealized for 1930s American audiences: there are no native Cubans present, and the geographical location is only of interest in providing a steamy place where propriety can be tossed aside. ◆*Carl Wilson*

Photo © Cbl62 (wikimedia commons)

Directed by Ray Enright
Scene description: In a Havana nightclub, dancers entertain an American audience
Timecode for scene: 0:27:07 – 0:32:41

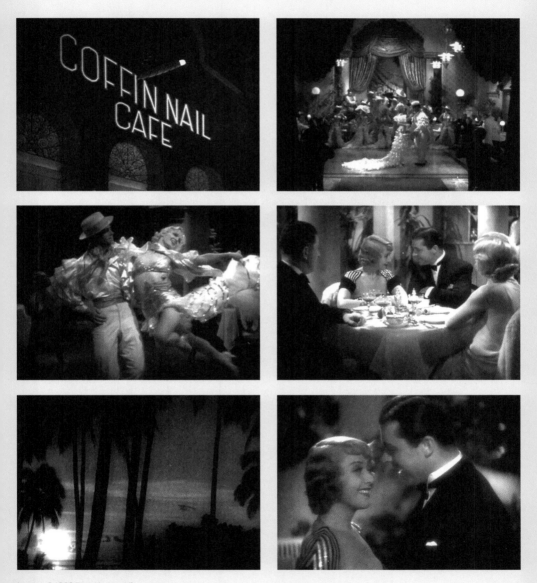

IT HAPPENED IN HAVANA/
ROMANCE DEL PALMAR (1938)

LOCATION *Paseo del Prado and the National Capitol Building (El Capitolio)*

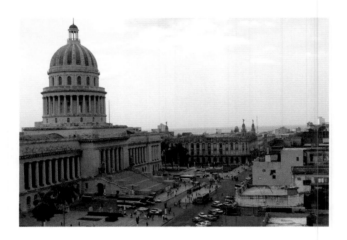

IN THE FIRST THREE DECADES of the twentieth century, Havana became
a thriving city, with approximately a half-million inhabitants by 1928. US
investment in the Cuban economy spurred on urban growth. Alongside colonial
fortresses, baroque churches and neoclassical buildings arose art deco homes and
new government buildings. Finished in 1929, the Capitolio was modelled on the
US Congress and signalled Cuba's exceedingly close ties to Washington. Such new
urban sights were of great interest to the country's nascent film industry. As one
of the island's earliest sound films, the musical *It Happened in Havana* showcases
the marvels of the modern metropolis, while expressing nostalgia for the simpler
rhythms of provincial life. The film follows the travails of Fe (Rita Montaner),
a young woman from the countryside. Seduced by a craven dandy, she ends up
in Havana where she finds fame as a nightclub singer in the exclusive cabaret
El Palmar. In the scene being treated here, after several extreme long-shots of
new city landmarks (e.g. the statue of independence hero Máximo Gómez, the
Presidential Palace, the Capitolio), we see Chucho, Fe's uncle, and his *compadre*
Cayuco arrive in Havana in search of Fe. Walking down the Paseo del Prado
with the Capitolio in the background, the two *guajiros* are portrayed as country-
bumpkins. They ask for directions to El Palmar, ignorant about its location and
about the nightlife aimed at foreign tourists and Cubans alike. The pair are almost
killed when they try to cross the street, their inexperience with automobile
traffic highlighted in several long-shots including a travelling shot from inside
the passing car that almost runs them down. While encouraged to laugh at their
ignorance, we also get to enjoy the urban sights along with them.
↝Laura Podalsky

Photo © Emma Rodvien

Directed by Ramón Peón
Scene description: Chucho and Cayuco appear against Havana's splendid cityscape
Timecode for scene: 0:59:03 – 1:02:20

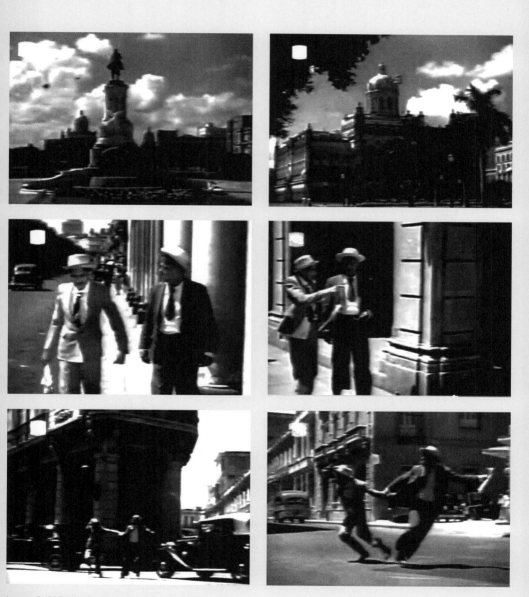

WEEKEND IN HAVANA (1941)

LOCATION *National Capitol Building (El Capitolio)*

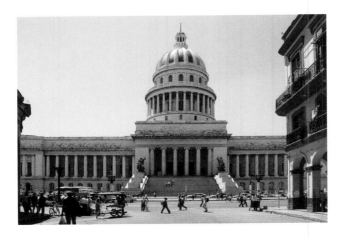

AS WITH MOST travelogue musicals and holiday romances to emerge from the Classic Hollywood system, *Weekend in Havana* was shot predominantly on studio stages in the United States. Unusually though, Twentieth Century Fox sent a second unit Technicolor crew to Havana to obtain authentic B-roll footage. Contemporary scenes of the Gran Casino Nacional, Oriental Park Racetrack, Sloppy Joe's Bar and Morro Castle are presented in a flurried montage that serves as a contextualizing prelude to the American contingency arriving by seaplane into Havana's modern industry-flanked harbour. Following this visual tour, when Nan Spencer (Alice Faye) enters the Presidential suite of her hotel, the Bellhop proudly presents her with a rear projected video backdrop of the National Capitol Building, exclaiming, 'There is no better view in the whole country.' Designed in the neoclassical style by Raúl Otero and Eugenio Rayneri Piedra, and constructed from 1926 to 1929, El Capitolio was used as the seat of government prior to the communist regime abolishing Congress in 1959. Nan is told that 'There is no place on this earth, it is so romantic [...] Here we have more alignments of the heart than any other place in the world'. Given that this foregrounded scene would have been shot in the United States, it is tempting to see the Cuban 'House of the People' as a romantic visual analogy to the Capitol building in Washington DC, where through the framing device of the 'Presidential' window, audiences are invited to see an exotic mirrored world in which love and romantic politicking can briefly supplant and parody American concerns with (self-)government.
⊸Carl Wilson

Photo © Gorupdebesanez (wikimedia commons)

Directed by Walter Lang

Scene description: Havana is introduced through a montage, and Nan then views the National Capitol Building through her hotel window

Timecode for scene: 0:12:56 – 0:14:47

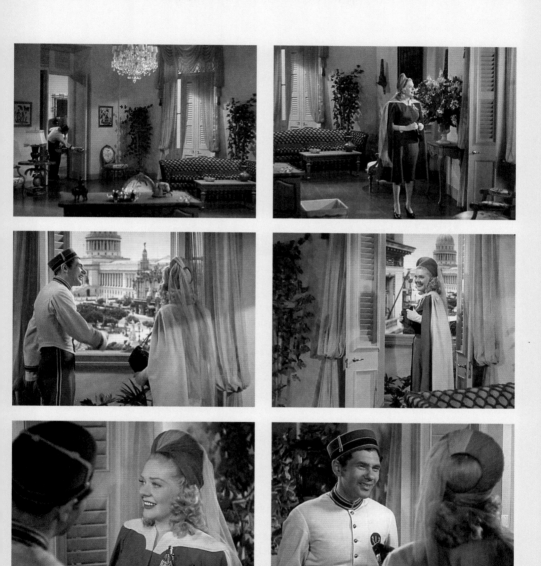

Images © 1941 Twentieth Century Fox Film Corporation

OUR MAN IN HAVANA (1959)

LOCATION *Sloppy Joe's Bar, corner of Ánimas and Zulueta Streets, Old Havana*

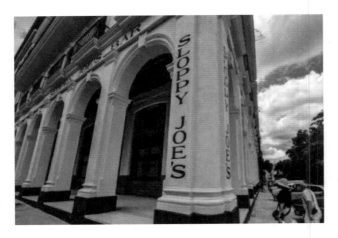

FILMED BY A BRITISH COMPANY just after the communist victory of 1959, *Our Man* presents the last days of the capitalist regime in Havana. Graham Greene, who was friends with Fidel Castro and also recruited by MI6 to perform spy missions in exotic locations, wrote the script. This suggests why the amusing recruitment scene at Sloppy Joe's Bar feels as though it might have details adapted from astute local experience. Before the revolutionary government 'nationalized' the bar, Sloppy Joe's had an iconic international reputation. After expanding a number of times, Sloppy Joe's had one of the largest mahogany drinks cabinets in the world – as Hawthorne remarks: 'I've never seen so many whiskeys.' During and after Prohibition in America, many tourists would flood to the legendary bar, which was frequented by celebrity patrons such as Ernest Hemingway and John Wayne; although filming immediately post-Revolution, the bar in *Our Man* is understandably devoid of a US presence. In *Our Man*, spy recruiter Hawthorne explains, 'A bar's not a bad place. You run into a fellow countryman, have a get-together. What could be more natural?' before saying of the toilets, 'you go in there and I'll follow you.' Given the fluctuating tone of the scene, and the shifting political climate in which the film was made (it was written pre-Revolution, and revised after it), the 'natural' authenticity of the Bar ties together all of these competing demands on the viewer and grounds them in the fixed reality of late 1950s Havana – an experience that can be revisited, since in 2013 the Bar was renovated and reopened. **Carl Wilson**

Photo © Google Earth

Directed by Carol Reed
Scene description: *At Sloppy Joe's Bar, Jim Wormwold (Alec Guinness) is approached by Hawthorne (Noel Coward) to be recruited into the British Secret Service*
Timecode for scene: 0:12:03 – 0:15:38

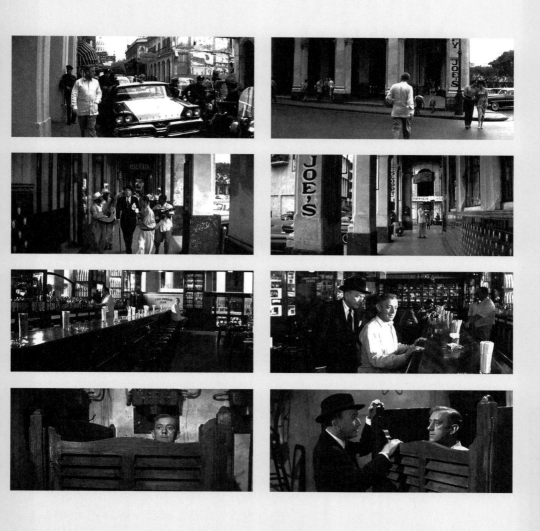

CINEMA SPACES

Text by
ANN MARIE
STOCK

DIRECTOR ENRIQUE COLINA joked that his feature film, *Entre ciclones/Between Hurricanes* (2003), was a box office hit not so much because of the acting or storytelling but because its release coincided with the oppressive summer heat; city-dwellers, eager for an air-conditioned reprieve, flocked to the cinemas in record numbers. And at the Águila cinema in Chinatown, where a TV monitor and DVD player have replaced the big screen and projection equipment, one suspects the matinee movie may attract young couples more for the intimacy of the darkened interior than for cultural edification. Still, Cubans' zeal for movies is remarkable. Each year a variety of events proffer space for film-going in the island's capital city and beyond.

Havana hosts the International Festival of New Latin American Cinema, an annual event showcasing recent production from the region. Every December since 1979, directors from across the Americas mingle with international stars and local spectators in some of the city's top venues. *Habaneros* pack movie theaters to celebrate films from afar as well as made-at-home features, animated films and documentaries. Some even plan their vacations to coincide with the Festival, so they can screen two, three, four or even more films each day. Outside popular cinemas like the Yara and the Chaplin, the line of hopeful ticket-buyers can span an entire block, turn the corner, and continue on down the street.

Each spring, emerging film-makers share their newly created work as part of the Young Filmmakers' Showcase (Muestra Joven ICAIC). The event, organized under the auspices of the National Film Institute (ICAIC), engages Cubans 35 and under in a variety of film-related activities – preparing the program and writing reviews, serving as jurors, participating on panels and in a series of debates, and seeking support for their next project in pitching sessions. Up-and-coming film-makers increasingly credit this space as critical for getting their work in front of audiences and crucial for establishing contacts important for their futures.

The past decade has witnessed the creation of a series of festivals and film events in various sites across Cuba. There is Cine Pobre (Low-Budget Film Festival) in Gibara, a documentary film festival in honour of the late Santiago Álvarez in Santiago de Cuba, the Mountain Cinema Festival in Jibacoa, and the Film Critics' Workshop in Camagüey.

In addition, the Televisión Serrana (Highland Television) has introduced film viewing and audio-visual production in the remote Sierra Maestra. For more than a decade, this media collective has been creating innovative works – sometimes humorous, sometimes heart wrenching – that capture the idiosyncrasies of life in this region's isolated mountain communities. Audio-visual artists then disseminate their work through the surrounding countryside. Screenings may take place in modest cultural centres outfitted with electricity, or (albeit

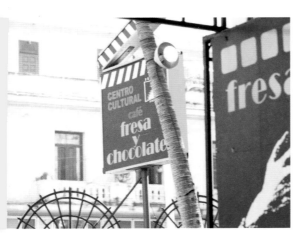

Above and Opposite © Kathy Hornsby

less frequently these days, as infrastructure in the area has improved) in tucked-away locales with equipment hauled in on the back of a mule.

Bringing films to people in the countryside has been a priority from the early years of the Revolution – as evident in Octavio Cortazar's poignant documentary *Por primera vez/For the First Time* (1967). Whereas mobile cinema units outfitted with a generator and projector were once needed to provide access to filmgoers in remote areas, this can be accomplished much more easily today with DVDs and flash drives. Video clubs serve viewers across the island. Even the smallest hamlets in the most remote areas boast a video club, sometimes simply a room in a modest home marked by a hand-lettered sign outside. Viewers in the provinces watch films the very same week they premiere in the capital; digital technology has eased significantly the process of reproduction and dissemination.

Film culture has expanded beyond the

Every December since 1979, directors from across the Americas mingle with international stars and local spectators in some of the city's top venues. *Habaneros* pack movie theaters to celebrate films from afar as well as made-at-home features, animated films and documentaries.

walls of cinemas, video clubs and screening venues. A plethora of film-themed cafes and restaurants have cropped up in Havana in recent years. Customers seeking a quick sip or a snack can stop in at the Rincón de Cine (Cinema Corner) in the Hotel Nacional or in the Fresa y Chocolate (Strawberry and Chocolate) cafe across the street from the Film Institute (ICAIC). A variety of family-run restaurants (*paladares*) serve up satisfying dishes across the city: the decor in Gringo Viejo features a poster advertising Gregory Peck and Katherine Hepburn in *Old Gringo* (Luis Puenzo, 1989); in the Centro Habana district, La Guarida permits diners to experience the site occupied by Diego and David in the acclaimed Cuban film *Fresa y chocolate/Strawberry and Chocolate* (Tomás Gutiérrez Alea and Juan Carlos Tabío, 1993); wine and *tapas* can be enjoyed indoors or on the open-air terrace in Madrigal, the artful Vedado locale which takes as its name the title of a Fernando Pérez film; and a restaurant named Bollywood has introduced flavourful Indian fare …

To happen upon a video club in the countryside, to sample the fare in a film-themed eatery, or to pass by one of the island's many cinemas – the Acapulco or Riviera, Actualidades or Novedades, Alegría or Maravillas, and even El Encanto – is to be reminded that in Cuba the magic of movies persists. ✣

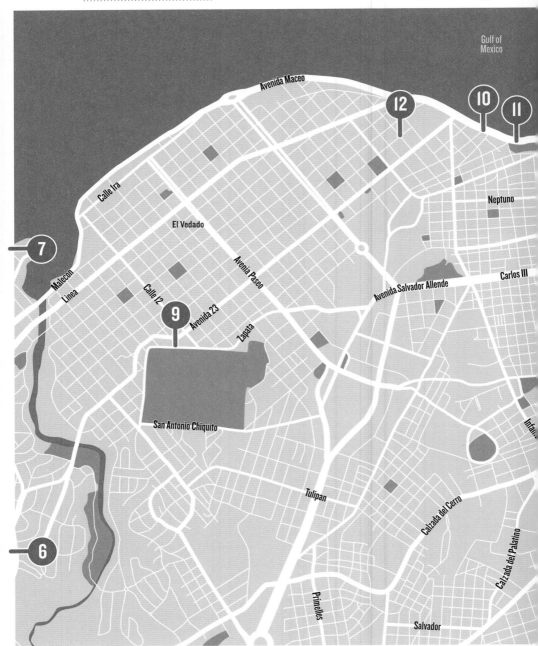

HAVANA LOCATIONS
SCENES 6-13

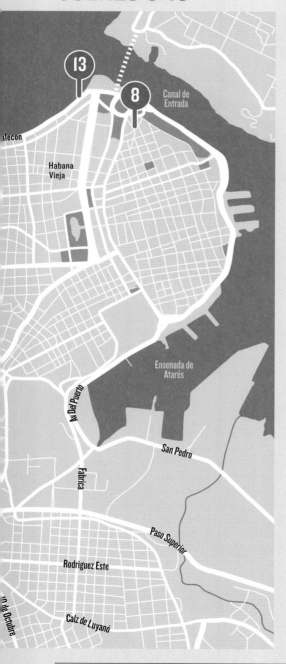

6.
CUBA DANCES/CUBA BAILA (1960)
Jardines de La Tropical, 41st Avenue
between 44th and 48th Streets, Playa
page 26

7.
PM (PASADO MERIDIANO) (1961)
5th Avenue between 116 and 120,
Playa de Marianao
page 28

8.
I AM CUBA/SOY CUBA (1964)
The intersection in Old Havana known as
'Five Corners'
page 30

9.
DEATH OF A BUREAUCRAT/
LA MUERTE DE UN BURÓCRATA (1966)
Entrance of Columbus Cemetery, at
Zapata and 12th Street, Vedado district
page 32

10.
MEMORIES OF UNDERDEVELOPMENT/
MEMORIAS DEL SUBDESARROLLO (1968)
The Malecón (Avenida de Maceo)
page 34

11.
ONE WAY OR ANOTHER/
DE CIERTA MANERA (1974)
The Malecón, where the statue of General
Maceo stands, in front of the Hermanos
Ameijeiras Hospital
page 36

12.
THE GODFATHER: PART II (1974)
Capri Hotel, 21st Street at N, Vedado
(actually filmed in the Dominican Republic)
page 38

13.
PORTRAIT OF TERESA/
RETRATO DE TERESA (1979)
On the Malecón looking across Havana's
harbour towards the Castillo de los Tres
Reyes Magos del Morro
page 40

CUBA DANCES/CUBA BAILA (1960)

LOCATION *Jardines de La Tropical, 41st Avenue between 44th and 48th Streets, Playa*

CUBA BAILA begins in La Tropical, one of the most frequented dance spots in 1950s Havana. Here, working-class people often came on weekends to meet friends and have a good time. Popular orchestras and singers performed while young and old, black and white, moved to the catchy rhythms of Cuban music. This location is not merely accidental in the film; it is a protagonist in the story of Ramón (Alfredo Perojo), a simple office employee, and Flora (Raquel Revuelta), a housewife who does some sewing in order to earn extra money for the family. Flora dreams of celebrating the fifteenth birthday of their daughter, Marcia (Vivian Gudé), in style; she would like to throw a *quinceañera* coming out party that would afford her daughter the status of young socialite and assure a happy marriage in the future. Flora schemes to make her dream come true – trying to influence her husband's boss to lend them money, striving to meet a prominent senator with connections – but is ultimately unsuccessful. The party is thrown not at an exclusive club but at the popular Jardines de La Tropical. The final scene takes us back to the outdoor gardens where people swing to the local rhythms. In *Cuba Baila*, premiering just after the triumph of the Revolution, working-class values win out over the false bourgeois consciousness. ➻**Mario Naito López**

Photo © Google Earth

Directed by Julio García Espinosa
Scene description: Marcia and Joseito waltz in Jardines de La Tropical
Timecode for scene: 1:18:46 – 1:20:15

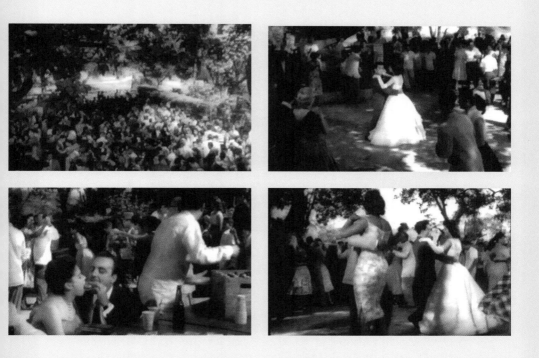

PM (PASADO MERIDIANO) (1961)

LOCATION *5th Avenue between 116 and 120, Playa de Marianao*

A 14-MINUTE BLACK-AND-WHITE documentary filmed in the pure style of *cinéma-vérité*, *PM* sparked a heated controversy – as did its eventual censorship – in a moment of strong ideological confrontation, just two years after the triumph of the Revolution. The action begins when a boat arrives from Regla (a town across the bay from Havana), and continues inside the port's bars where people listen to music and drink, dance and debate, seemingly oblivious to the country's political transformations. The film later moves to Marianao Beach, located to the west of Havana, a popular destination for swimmers and night owls since the 1920s. Looking out from a moving car, the camera captures the food vendors along 5th Avenue, until it settles upon Chori, a legendary percussionist whose admirers included notable figures like Marlon Brando and Agustín Lara. In the dim light, the musical group warms up gradually and then plays a bolero. Couples dance as Chori sets the rhythm by clinking glass bottles. The atmosphere is more relaxed than in the waterfront bars. At the end of the night, the bar-hoppers sip their last drink and eat their final sandwich, after which the boat returns to Regla. Silvano Shueg (Chori) would later die in 1974 shrouded in anonymity. *PM* was not shown again on Cuban television until 50 years after its premiere. ⦾ *Pablo Fornet*

Photo © Google Earth

Directed by Sabá Cabrera Infante and Orlando Jiménez Leal
Scene description: Traditional Cuban music contributes to the atmosphere in a night-time sequence
Timecode for scene: 0:08:56 – 0:11:40

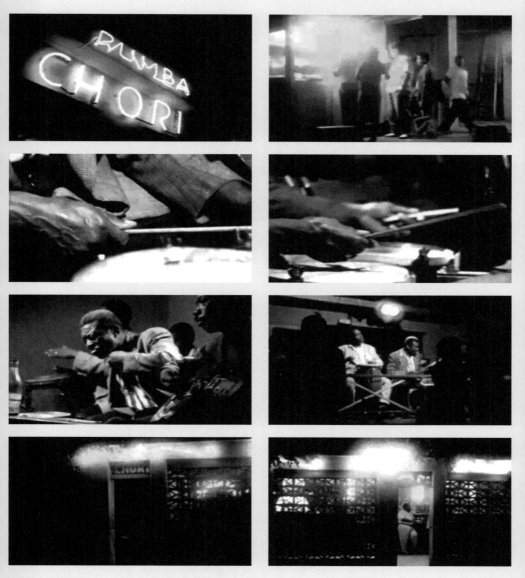

Images © 1961 Sabá Cabrera, /Alberto Cabrera and Orlando Jiménez Leal

I AM CUBA/SOY CUBA (1964)

LOCATION *The intersection in Old Havana known as 'Five Corners' where the streets Habana, Espada and Cuarteles come together*

SOY CUBA IS A VISUALLY STUNNING portrait of a country on the brink of revolution. Co-produced by the Soviet Union and Cuba, co-written by Russian poet Yevgeny Aleksandrovich and Cuban novelist-playwright-film-maker Enrique Pineda Barnet, this is, from the opening sequence, an enduring work of avant-garde world cinema. For contemporary viewers, it is difficult to imagine a film so visually rich without post-production special effects. Russian cinematographer Sergei Urusevsky and a team of Cuban specialists deployed a remarkable range of innovative techniques to present a critical, celebratory and impressionistic representation of a nation in transition. The film's inventive visual poetry is achieved through gravity-defying long-takes, wide and extreme angles, elaborate camera rigs, and handheld camera movements. One breathtaking sequence – a single take – chronicles the funeral procession of a martyred student. Beginning with a handheld low-angle shot, the camera tracks then ascends, revealing a crowded narrow street where a funeral entourage processes while foregrounding mourners on balconies tossing down flowers. The camera continues to rise, pausing atop a terrace before moving forward and tracking right into a cigar factory where workers pass and unfold the new Cuban flag. This flag unfurls and the camera then travels through the window to resume its gaze on the procession; miraculously suspended in the air, it moves forward observing the crowded street, the mourners on balconies and the flag-draped casket. Rich with connotations of remembrance, solidarity and forward progression, the camera encapsulates the bourgeoning Revolution. Lost for many years, *Soy Cuba* was rediscovered and later distributed. In its inventive observation of the overdetermined factors of the Cuban Revolution, this is a celebration of cinematic representation itself. ↦**M. Troy Davis**

Photo © Troy Davis

Directed by Mikhail Kalatozov
Scene description: A funeral procession in Old Havana
Timecode for scene: 1:44:40 – 1:47:30

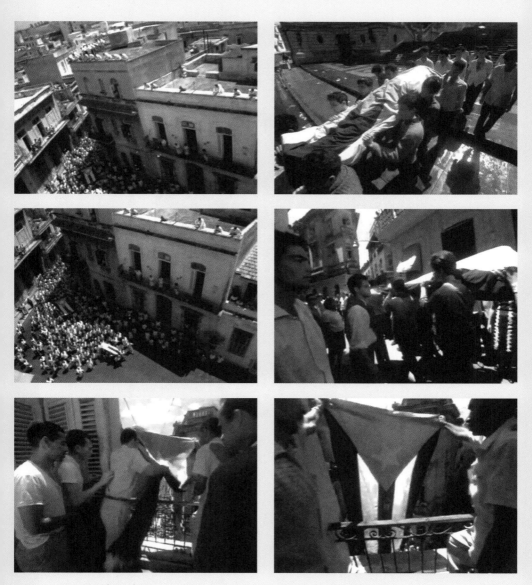

Images © 1964 Mosfilm (Russia)/Instituto Cubano del Arte e Industria Cinematográficos (ICAIC)

DEATH OF A BUREAUCRAT/
LA MUERTE DE UN BURÓCRATA (1966)

LOCATION *Entrance of Columbus Cemetery, at Zapata and 12th Street, Vedado district*

COLUMBUS CEMETERY (Cementerio Colón) is the largest one of its type in America and considered the third most important in the world. Built in 1886, the massive portico is made of Carrara marble extending 34 metres in length and 21 metres in height. Like virtually every other cemetery, this is a place of calm and peace, respected by everyone. But this changes in Tomás Gutiérrez Alea´s *Death of a Bureaucrat,* where the locale serves as a vehicle for black humour. A man (Salvador Wood) whose uncle-in-law is buried in his grave with his union card, requires this document to register the widow (Silvia Planas) as the beneficiary of a pension. After numerous bureaucratic tangles, the nephew decides to take matters into his own hands. He opens the coffin where the corpse lies in the Cemetery, and succeeds in recovering his uncle's work credentials. But then another problem arises, that of burying the corpse again. The ensuing attempts at interment are as wacky as the film-maker is witty. Alea's brilliant black comedy pays homage to Luis Buñuel's surreal *Un chien andalou* (1929) and to the great slapstick American comedians of the silent era, especially in the sequence of the fight at the entrance of the Cemetery. **+Mario Naito López**

Cuban slapstick

Directed by Tomás Gutiérrez Alea
Scene description: Fight at the entrance to Columbus Cemetery (Cementerio Colón)
Timecode for scene: 0:31:29 – 0:34:15

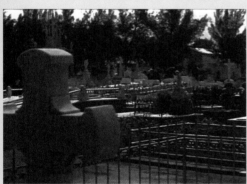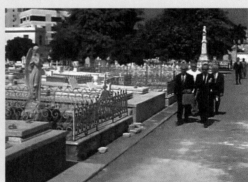

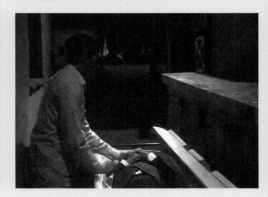

MEMORIES OF UNDERDEVELOPMENT/ MEMORIAS DEL SUBDESARROLLO (1968)

LOCATION *The Malecón (Avenida de Maceo)*

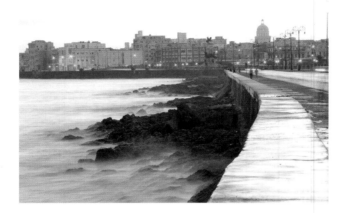

IN TOMÁS GUTIÉREZ ALEA'S groundbreaking study of one man's attempt to come to terms with the Revolution, Havana's roadway and sea wall, the 8 kilometre Malecón takes centre stage. Early in the film Sergio looks down on the statue of General Maceo on the Malecón, hero of Cuban independence and revered macho, and comments ironically on how Cuba is now free and independent. At the end of the film he again uses his telescope to look down on the Malecón as the country prepares itself for possible invasion by US backed forces; lines of army trucks pulling military canons move slowly past the front of the Hotel Nacional. The Malecón, then, is a site of revolutionary, macho resistance lined with monuments to great Cuban heroes such as Máximo Gómez, Antonio Maceo, Calixto García, José Martí and the Monument to the Victims of the USS *Maine*. Strength, machismo, resistance (both to the elements and to external capitalist forces) are all linked with the Malecón here as Sergio, misogynist womanizer and hopeless writer, looks down on it from his apartment a couple of blocks away. As culture is grounded in place and space, landscape images and these images act as 'settings for the activities that embody self and society' (Aitken and Zonn, p. 3), so the Malecón here embodies the macho attitudes that Sergio possesses, and acts as Sergio's alter-ego, linking him through his voyeuristic stare with his machismo.
↠*Guy Baron*

Photo © Kathy Hornsby

Directed by Tomás Gutiérrez Alea
Scene description: Sergio looks down on the Malecón
Timecode for scene: 1:42:25 – 1:43:35

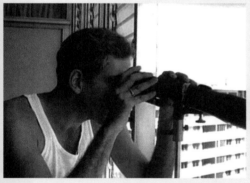 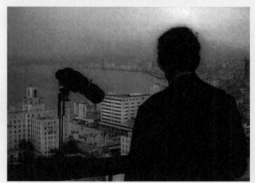

ONE WAY OR ANOTHER/
DE CIERTA MANERA (1974)

The Malecón, where the statue of General Maceo stands, in front of the Hermanos Ameijeiras Hospital

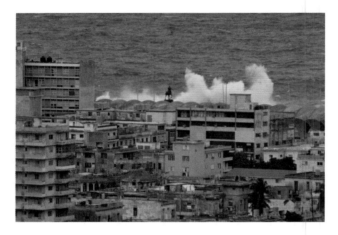

SET DURING THE EARLY 1960S, *One Way or Another* tells a love story that strikes at the heart of machismo in Cuba; it examines two young people and their attempts to change their views on society and, in particular, Mario's views on male/female relations. Throughout the film Mario finds that his traditional macho beliefs no longer sit comfortably in the new, revolutionary Cuba. Critics have noted the importance of location to the film's narrative structure; this gives a clue to the film-maker's desire to baulk at history and the extremely negative male/female binary in Cuba. When Mario says that he acted 'like a woman' he is standing beneath the statue of General Maceo, a hero of the wars of independence and a hugely venerated macho figure in Cuban history. The film emphasizes the Althusserian link between a state-sponsored ideology that connects war and heroic deeds with machismo. By doing so through a character's consciousness-raising process that is forcing him to question these beliefs, it is critiquing this link. This scene is contrasted with those where Yolanda and Mario make love. Here, in a room where history cannot enter, Mario relinquishes his macho attitude and becomes sensitive and caring, the type of man in Gómez's eyes that the Revolution is trying to create. The film's brilliance lies in its ability to express the reality of Cuba's historical macho condition while at the same time suggesting some of the possibilities for change. **→Guy Baron**

Photo © Troy Davis

Directed by Sara Gómez
Scene description: Mario regrets betraying his friend
Timecode for scene: 1:04:25 – 1:05:13

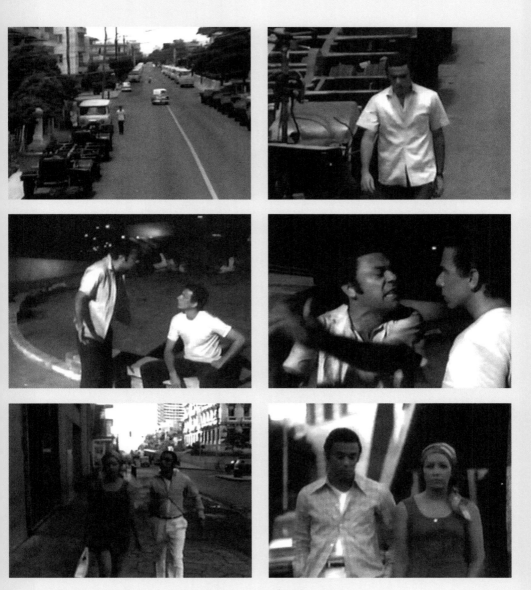

THE GODFATHER: PART II (1974)

LOCATION

*Capri Hotel, 21st Street at N, Vedado
(actually filmed in the Dominican Republic)*

HYMAN ROTH (LEE STRASBERG) is old and sick and wants out of the Cuba 'business' in a suspicious hurry so he meets with the heads of the families on the terrace of the Capri Hotel in Havana, two blocks from the Hotel Nacional. On the occasion of his 67th birthday and retirement he shares out his costly investments and links to President Batista in the form of pieces of an over-egged birthday cake shaped like the island: 'The hotels here are bigger and swankier than any of the rough joints we put in Vegas and we can thank our friends in the Cuban government which has put up half the cash.' True: in 1955 Batista's Hotel Law 2070 had offered tax-breaks, loans and gambling licences to anyone wanting to build million-dollar hotels in Cuba and Meyer Lansky (author Mario Puzo's model for Roth) had not only taken the bait but swallowed Havana whole. But Michael Corleone (Al Pacino) has had his appetite ruined by his drive into the city from the airport, when he saw a young revolutionary prepared to kill and die for a cause greater than money: 'It occurred to me that the soldiers are paid to fight, the rebels aren't.' 'What does that tell you?' sneers Roth at this party-pooping *padrino*. Michael considers his options against the pending sunset over Havana and turns them into a single, inevitable conclusion: 'They can win.' **Rob Stone**

Photo © Kathy Hornsby

Directed by Francis Ford Coppola
Scene description: Michael contemplates Cuban rebel activity while attending Roth's birthday party
Timecode for scene: 1:17:47 – 1:21:24

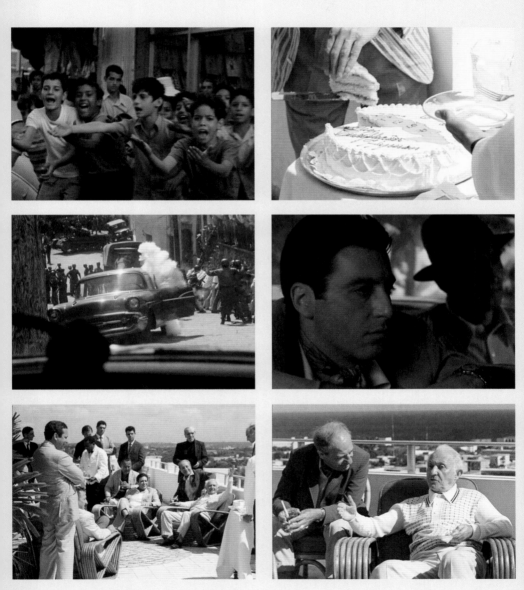

PORTRAIT OF TERESA/
RETRATO DE TERESA (1979)

LOCATION *On the Malecón looking across Havana's harbour towards the Castillo de los Tres Reyes Magos del Morro*

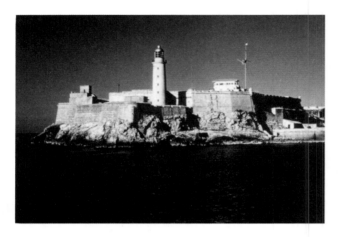

SYMBOL OF PATRIARCHY, 'a phallic marker that permeates cultural thought and oppresses female subjectivity' (Álvarez, p. 91), the lighthouse within Havana's castle overlooking the city's harbour has been a feature of a number of recent Cuban films, including Fernando Pérez's *Suite Habana/Havana Suite* (2003). In Pastor Vega's *Portrait of Teresa*, Teresa's husband Ramón takes a photograph of his wife while their three children run happily along the Malecón. As Teresa's hair blows across her face giving her a sensuous vitality, the phallic marker looms poignantly in the background; the apparent innocence of the scene is questioned throughout the film as Teresa's typical 'portrait' taken by her husband is complicated by efforts to create new revolutionary men and women. The lighthouse in the background symbolizes the pre-revolutionary, patriarchal and unequal Cuba while the film goes on to convey that efforts to redress the balance for women have not been entirely successful after twenty years of revolution. The picture painted at the beginning of simple and happy domesticity is shown to be false as the film progresses, and the couple eventually splits up. Teresa frees herself from her husband's overbearing dominance, walking away spirited and independent but into an uncertain future. **⇒Guy Baron**

Photo © Dr. Anthony R. Picciolo (wikimedia commons)

Directed by Pastor Vega
Scene description: Teresa and family on a day out
Timecode for scene: 0:00:17 – 0:01:13

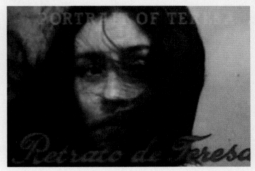

IMITATIONS OF CUBA

Text by
ROB
STONE

THE VISION OF CUBA presented by Cuban cinema is one thing; quite another is the view of the nation offered by films made elsewhere. The commercial embargo imposed on Cuba by the United States in October 1960 became a virtual blockade in February 1962 and a law in 1993 that was strengthened in 1996 and 1999, making filming in Cuba impossible. As a result, searching for Cuba in non-Cuban films that have the island as subject or backdrop reveals remnants of its past and suggestions of its future embalmed in a fanciful yet stagnant present. Appearing as Cuba is never actually Cuba, of course. It is Spain, Mexico, Uruguay, Puerto Rico, the Dominican Republic or a Californian soundstage describing an imagined community with a masquerade of entertaining vistas and servile stereotypes that pander to the demands of outsiders for exoticism, threat and the corroboration of prejudice.

Many of the films that feature this excuse for Cuba do so via a structuralist approach to the prevalent myth. The checklist (and possible drinking game) starts with music, of course, lilting rhythms and maracas, then chubby cigars, swaying

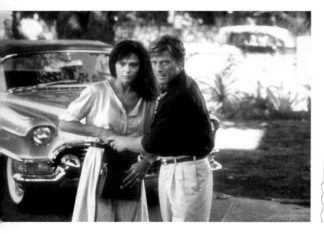

palm trees, crumbling colonial buildings and dusky *mulattas* in brightly coloured clothes whose sexual availability is, if not explicit, certainly open to negotiation. There are waves, dawn and often both breaking over a substitute Malecón, expats in linen suits and existential malaise, the outsized tin-toys of 1950s automobiles and fluorescent green cocktails. This chain of signifiers is compiled behind the credits of *Cuba* (Richard Lester, 1979), for example, that was filmed entirely in Spain, whereby it sustains the dominant myth of Cuba in non-Cuban cinema.

The evolution of Cuba is irrelevant to these symbols, which signify only stagnancy. They also prop up the flaccid erotic thriller that is *Original Sin* (Michael Cristopher, 2001), which is set in colonial times and filmed in Mexico, where these signs are arranged in a manner that is not authentic or arbitrary but constructed and naturalized to perpetuate the myth of Cuba as frozen in time, which is a myth that freezes time itself. When the action of the film is contemporary, moreover, these signs still point to pre-revolutionary Cuba as the signified. Even when the Revolution is represented, Guevara and Castro signify only a momentary lapse in the rigidity of the myth that neutralizes their significance much as the iconic image of Ché Guevara was appropriated by Madison Avenue.

That this checklist of signifiers has endured long after the Revolution while pointing invariably to pre-Revolution Cuba is demonstrated by *Dirty Dancing: Havana Nights* (Guy Ferland, 2004). Filmed in Puerto Rico, and set in 1959, the film was about as sensitive to Cuban history as it was authentic: 'Where's the revolution tonight? On the dance floor!' Also set in the amber of this mythical 1959 are *The Godfather: Part II* (Francis Ford Coppola, 1974), *The Lost City* (Andy García, 2005) and *Havana* (Robert Redford, 1990), which were all filmed in the Dominican Republic.

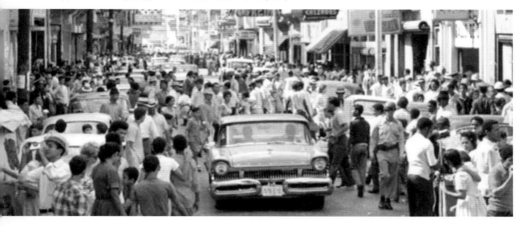

This myth, as Barthes describes, has an imperative, buttonholing character that passes from semiology to ideology, albeit a stagnant one. Many countries have their signifying chains – elephants, trains and temples for India, or bulls and flamenco for Spain – but whereas these commonly situate the film and the audience in a place, the signs that point to Cuba do not reveal a place – which is disallowed by the embargo – but a time. In effect, they situate the audience in a temporal freeze-frame in which and by which the semiological system transcends itself and becomes a factual system. There is no poetry here. Instead, this repetition gives way to rigidity, by which contemporary Cuba remains a product, rather than a process. That is to say, this myth is a time that defines a place. Here, according to Henri Lefebvre, who theorized the control of capitalist institutions over space, we should be able to see the signified myth of Cuba in terms of its social function, as something that can be classified as either a basic natural space, which simply exists, or as a social space that both affects and is affected by its inhabitants. However, this chain of signifiers is so rigid that it prohibits this because the represented space is unchanging, suspended and frozen, so persistent and insistent that it has never been reclaimed and reterritorialized as an arena of thought and action in films depicting Cuba from outside Cuba.

Even in recent films in which Cuba is the imagined backdrop to a number of drug-fuelled, action-filled thrillers, the chain of signifiers remains largely intact. *Die Another Day* (Lee Tamahori, 2002) is a Bond film in which the role of Havana is taken by the city of Cádiz on Spain's southern coast; *Bad Boys 2* (Michael Bay, 2003) follows cops tracking Floridian drug-money back to Cuba, which is played by Puerto Rico; and Uruguay plays the island in the neo-noir *Miami Vice* (Michael Mann, 2006). Even in recent period films such as *The Good Shepherd* (Robert De Niro, 2006), which stars the Dominican Republic, and *Antes que anochezca/Before Night Falls* (Julian Schnabel, 2001), where the role is essayed by Mexico, the blockade of Cuba is justified by the criminality that is filmed elsewhere.

Time and time again, therefore, audiences are expected to construct Cuba out of signifiers with pre-fabricated meaning. Reality is not transformed but repeated by this visual code of songs, cocktails, cigars and easy women to the extent that representations of Cuba have become copies of copies of copies. This Cuba is a photograph of a wax museum in which neither the authentic past, nor the real present, nor any sense of a coherent future are referenced. Consequently, to the extent that this semiotic language exists to signify the imagined community of Cuba, its construction of a cinematic equivalent to the actual island is ironic because the revolutionary potential of this imitation of a mock-up of a myth is frustrated, stifled and refused by signs that are stereotypical, retrograde and racist. In sum, they present an alternative, foreign cinematic history of Cuba, one that constitutes a challenge to be overcome by Cuban cinema itself. ✤

There are waves, dawn and often both breaking over a substitute Malecón, expats in linen suits and existential malaise, the outsized tin-toys of 1950s automobiles and fluorescent green cocktails.

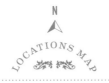

LOCATIONS MAP

HAVANA

maps are only to be taken as approximates

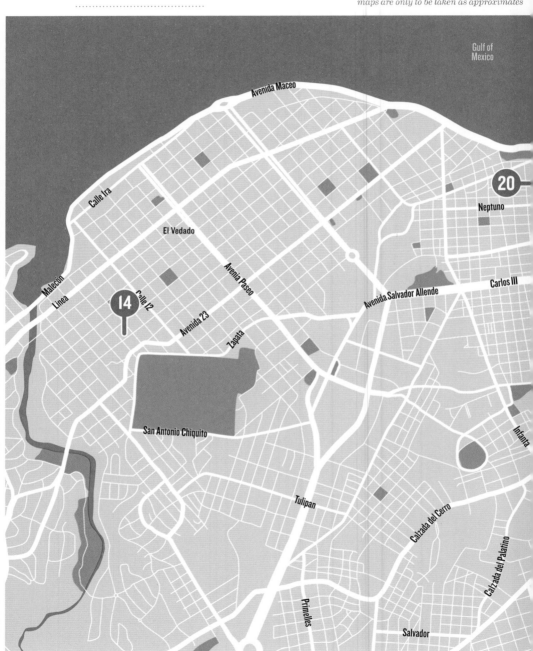

Gulf of Mexico

Avenida Maceo

Calle 1ra

El Vedado

Avenia Paseo

Malecón

Linea

14 Calle 12

Avenida 23

Zapata

Avenida Salvador Allende

Carlos III

20

Neptuno

San Antonio Chiquito

Infanta

Tulipan

Calzada del Cerro

Calzada del Palatino

Primelles

Salvador

HAVANA LOCATIONS
SCENES 14-21

HOUSE FOR SWAP/SE PERMUTA (1983)

LOCATION *1108 1/2 19th Street between 14 and 16, El Vedado*

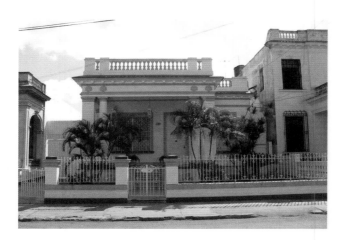

JUAN CARLOS TABÍO, a disciple of and collaborator with the legendary Tomás Gutiérrez Alea, earned critical acclaim with this social comedy. While the film pokes fun at housing problems in Cuba, it also invites a reflection on ways of life – and ways of getting by and making do – in the country at that time. Adapting his own stage play, at the urging of his mentor Alea, Tabío proved talented in managing characters and situations. Gloria, an attractive middle-aged woman (Rosa Fornés), lives with her daughter Yolanda (Isabel Santos) in Guanabacoa. She hatches a plot to move from this remote area outside Havana to the fashionable Vedado district, in order to find a good husband for the girl. House swapping – an agreement between the residents of various dwellings – was, for many years in revolutionary Cuba, the only way of moving to a new home. What Gloria failed to consider in her scheming, however, is that her daughter would fall for Pepe, a *mulatto* (Mario Balmaseda). She opposes the relationship, preferring instead Guillermito (Ramoncito Veloz), a clever suitor who plans to marry Yolanda. Appealing to major audiences, *House for Swap* exemplifies the films developed by Cuba's National Film Institute (ICAIC) in the 1980s, which satisfied Cuban spectators who packed the cinemas. **→ *Mario Naito López***

Photo © Google Earth

Directed by Juan Carlos Tabío
Scene description: Pepe meets Yolanda in her apartment in the Vedado district
Timecode for scene: 0:28:22 – 0:30:22

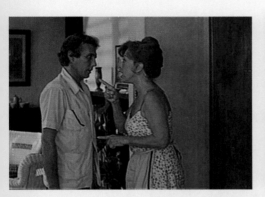

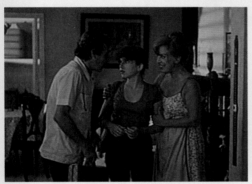

VAMPIRES IN HAVANA/
VAMPIROS EN LA HABANA (1985)

LOCATION *Unidentified cinema like El Payret across from the Capitolio*

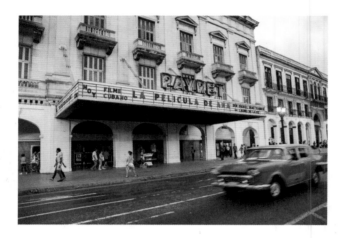

IMAGINE A STORY in which clandestine vampire societies and Chicago
gangsters battle over a magic potion; in which vampire tales collide with love
stories and international espionage. Now, imagine all this set to the backdrop
of 1930s Havana. As absurd as this may seem, *Vampires in Havana* brings this
whirlwind story to life, transforming its colourful eccentricities into an animated
masterpiece. The plot unfolds with hysterical intrigue: exiled vampire Werner
Amadeus von Dracula - son of the infamous Count Dracula – arrives in Cuba,
where he develops a potion that allows vampires to withstand sunlight; he
secretly tests it on nephew Pepito, a hip trumpeter blissfully unaware of his
vampire heritage. When word of the groundbreaking potion reaches foreign
vampire syndicates – namely the European Vampire council and a Chicago-
based vampire gang – Pepito and Werner are propelled into a battle to protect the
potion from greedy foreign interests. After Werner entrusts his nephew with the
secret formula, Pepito hides in a movie theatre to evade his rival vampires. This
refuge provides Pepito little comfort, though, as the film showing there happens
to be the classic vampire tale *Dracula* (Tod Browning, 1931). In a brilliant fusion
of film techniques, the cartoon spectators view *Dracula* in its original celluloid
format, their soft, animated forms contrasting with the sharpness of the film on
the screen within the frame. This fusion of style and technique echoes the larger
synthesis of genre, cinematography and plot that *Vampires* so eloquently – and
frenetically – produces. Cartoon humans watch real-life actors playing fictional
vampires in an animated Cuban setting. Difficult to imagine, yet wonderful to
watch. ❖***Emma Rodvien***

Photo © Kathy Hornsby

Directed by Juan Padrón
Scene description: Pepito hides in a movie theatre
Timecode for scene: 0:48:50 – 0:51:44

 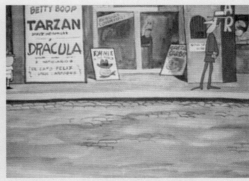

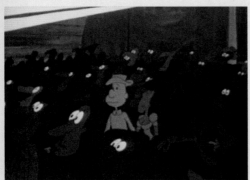 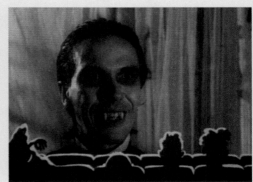

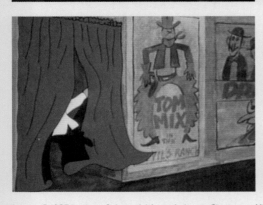 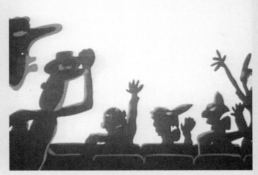

THE BELLE OF THE ALHAMBRA THEATRE/
LA BELLA DEL ALHAMBRA (1989)

LOCATION

Alhambra Theatre, fictionally designed at the corner of Muralla and Bernaza Streets, simulating the real location at the corner of Consulado and Virtudes (pictured here Gran Teatro on Paseo del Prado)

THE ALHAMBRA THEATRE opened in 1890, initially offering Spanish operettas and acts to the audiences in the heart of Havana. In the course of only one year, these shows were replaced by Cuban fare. Glamorous women danced and sang in vaudeville-style shows and erotic skits designed to entertain male spectators. Performances at the Alhambra continued without interruption from the beginning of the twentieth century until 1935. Drawing inspiration from Miguel Barnet´s novel about this venue, *Canción de Rachel/ Rachel's Song* (1969), Enrique Pineda Barnet directed *The Belle of the Alhambra Theatre*. The film, arguably Cuba's first artistically significant musical, centres on a poor but very attractive brunette who is fascinated by musical theatre. Besides portraying the belle and the Alhambra, the musical also tells the story of republican Cuba. Rachel (Beatriz Valdés) lives with her mother (Veronica Lynn), a middle-aged woman exploited by an unscrupulous younger man (Ramón Veloz), who also seduces the impressionable Rachel. In a rags-to-riches tale, Rachel ascends from a simple chorus girl in a local fair to the star of the Alhambra. It is thanks to her beauty and talent, as well as to the favours of wealthy politicos and businessmen, that she makes her way to the top. All the while, Rachel must face the fierce and fiery backstage world; she is assisted by her gay friend and confident, Adolfito (Carlos Cruz), but ends up sacrificing her first true love (Jorge Martínez). At film's end, an elderly Rachel – now an Alhambra relic – remembers the tribulations of her tumultuous life.

ᴼᵈ Mario Naito López

Photo © Emma Rodvien

Directed by Enrique Pineda Barnet
Scene description: Rachel, outside the Alhambra Theatre, dreams of starring in a show
Timecode for scene: 0:05:49 – 0:07:11

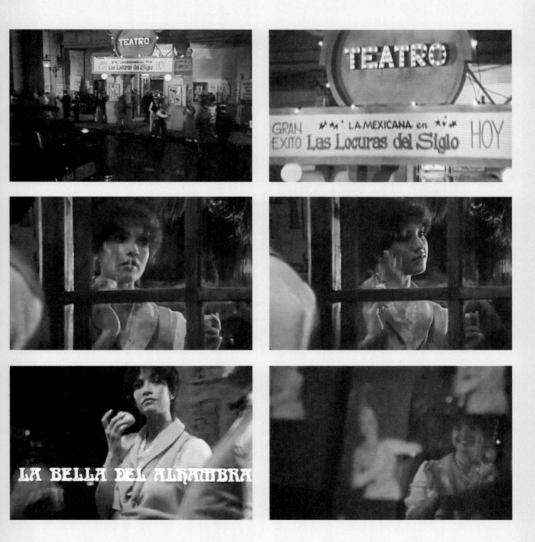

SUPPORTING ROLES/
PAPELES SECUNDARIOS (1989)

Numismatics Museum, Obispo Street 305, Old Havana

ORLANDO ROJAS'S second feature-length fiction film challenged many of the stereotypes associated with earlier Cuban cinema. Shot mainly in interiors in the Terry Theatre in Cienfuegos, the action pretends to takes place on a stage in Havana, and shows other locations like the Havana University Stadium and the rooftop of the Numismatics Museum in Old Havana. The film-maker set an ambitious agenda with this work – viewing everyday life from inside a theatrical group so as to analyse contemporary Cuban society, and staging a play as a strategy for exploring the contradictions among some of the central characters. Mirta (Luisa Pérez Nieto) is an actress who plans on leaving her theatrical group. But that plan changes with the arrival of a new stage director (Juan Luis Galiardo) who brings a refreshing artistic vision. Personalities clash and tensions mount: the head of the group becomes ever more tyrannical (Rosa Fornés); several young actors are assigned to the theatre and change the group's dynamic; and an inspector (Carlos Cruz) comes to check over the place. With its striking visuals, richly coded significance, superb editing and innovative musical score, the film remains one of the highlights of Cuban cinema of the 1980s. ➻*Mario Naito López*

Directed by Orlando Rojas
Scene description: Pablo and others escape to the rooftop
to get away from the tensions inside the theatre
Timecode for scene: 0:36:24 – 0:40:05

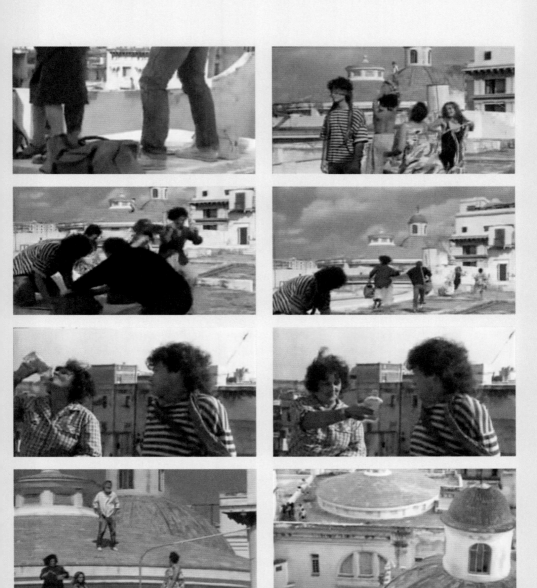

HAVANA (1990)

LOCATION *On the Paseo del Prado near the Hotel Inglaterra*

SYDNEY POLLACK AND ROBERT REDFORD argued at length with the US State Department about gaining permission to bypass their embargo on Cuba and shoot *Havana* in Havana. But to no avail, so *Havana* was shot in the neighbouring Dominican Republic. Aesthetically similar in many Caribbean features, the Dominican Republic's capital city, Santo Domingo, was a stand-in that lacked one significant detail: an equivalent to Havana's Paseo del Prado. El Prado is a European-style boulevard comparable to those found in Paris and Madrid. Built from 1770 to the mid-1830s, the iconic thoroughfare is lined by the National Capital Building (El Capitolio), several hotels, theatres and restaurants. Pollack's solution was to build 'The Big Set' at San Isidro Air Base, 25 kilometres east of Santo Domingo – the only place big enough to hold a half-kilometre-sized, neon-lined, simulacrum of El Prado, circa 1958. At the climax of *Havana,* word has spread that General Batista has left Cuba. The scene cuts from a New Year's party at the Capitol Building to El Prado as nightly chaos descends. American tourists and the Cuban military pour into the streets to flee in desperation, whilst the citizens of Havana destroy capitalist symbols of the oppressive regime. The *Casablanca*-esque Robert Redford/Lena Olin-romance storyline becomes entirely emotionally usurped by the sheer ferocity, confusion, fear and relief presented in the moment in which a landmark piece of Cuban revolutionary history is passionately re-enacted on the El Prado replica. **↝Carl Wilson**

Directed by Sydney Pollack
Scene description: *At night, thousands of people flood onto the streets of Havana*
Timecode for scene: *2:00:15 – 2:04:11*

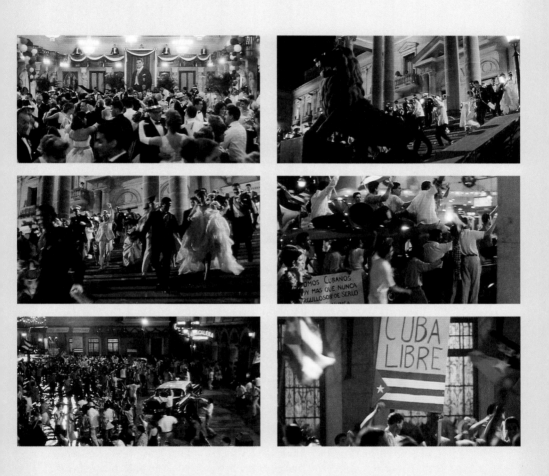

HELLO HEMINGWAY (1990)

Finca Vigía (Ernest Hemingway's home) in San Francisco de Paula

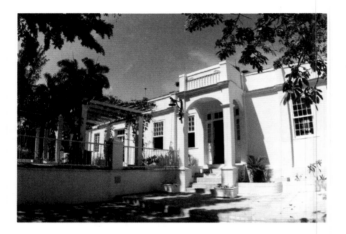

FINCA VIGÍA IS THE HILLTOP HOME where Ernest Hemingway lived and reigned in Cuba. Although the property has been a museum since 1962, many visitors claim to still feel the presence of the powerful North American writer. Legends abound ... many about the swimming pool where Hemingway apparently encouraged his guests to bathe, as he did, in the nude. He purportedly coaxed the beautiful actress, Ava Gardner, to baptize the waters with her naked body. Given its mythic proportions, it is not surprising that the Finca Vigía has served as a location for various Cuban and international films. Cuban director Fernando Pérez selected Hemingway's home and environs for the story of Larita, a young woman of modest means from San Francisco de Paula who dreams of becoming a writer. *Hello Hemingway*, set in 1956, begins with an image that becomes a recurrent symbol in the film: the tower at the Finca Vigía. Tall, white, distant, immaculate, it constitutes an expression of power and glory in marked contrast to the precarious conditions in the surrounding area. The image of the tower gives way to a shot of Larita and her cousin Flora playing in the swimming pool, transgressing a space that is private and prohibited. The butler sends them away as an amused Hemingway watches through one of the bungalow's windows with a smile of complicity. In the film, Hemingway and Larita never meet; they only see one another from a distance. As Pérez has said: 'For Larita, Hemingway represents something unattainable, an illusion, a dream.'
⊷Miryorly García Prieto

Photo © David Lansing (wikimedia commons)

Directed by Fernando Pérez
Scene description: Larita and her cousin sneak into the pool at the Finca Vigía
Timecode for scene: 0:00:00 – 0:02:38

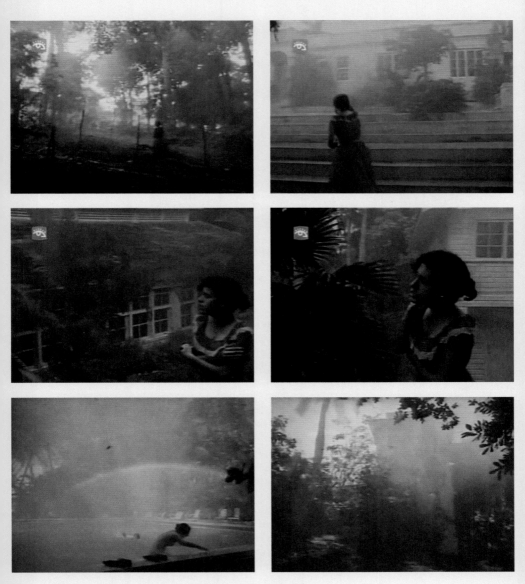

STRAWBERRY AND CHOCOLATE/ FRESA Y CHOCOLATE (1993)

LOCATION *La Guarida, Concordia No. 418 between Gervasio y Escobar, Centro Habana*

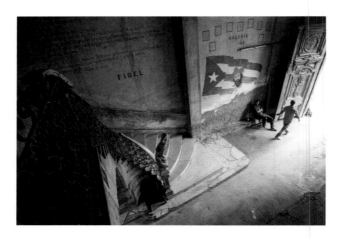

NOW CONSIDERED ONE OF THE BEST restaurants in Havana (La Guarida), Diego's apartment in Tomás Gutiérrez Alea's Oscar-nominated film is both a symbol of the claustrophobia, entrapment and danger that has at times enveloped members of Cuba's literary class, and of the possibilities of change, of moving forward in to a more tolerant and open future. The Cuban flag and quotation by Fidel Castro painted on the wall in the crumbling entrance to the building introduces us to the constant vigilance suffered by those considered as counter-revolutionaries. Having to hide from neighbours as Diego takes David up to his apartment, the necessity to play music so that no one can hear your conversation, religious artwork, evidence of banned literature and the extravagances of a bourgeois and excessively camp sensibility build a picture of Diego's forbidden world in the place he describes as his 'hideaway'. Behind the facade of revolutionary slogans, then, lies a world that provokes suspicion but also intrigue for Communist Party Youth member David. Long sequences are filmed in Diego's 'lair', the accumulation of artefacts and the restricted space adding to the oppressive and illicit but alluring quality of the place. The later sequences focus less on the apartment itself and more on the people in it, thus pointing to the director's desire to emphasize the human rather than the material as the basis for change. At the end of the film the apartment becomes something different; almost devoid of the trappings of Diego's forbidden world it becomes both the site of David and Nancy's physical union (thus alleviating the apartment of any homosexual collusion) but also of David and Diego's embrace and hence the site of tolerance and future possibility. **⇢ Guy Baron**

Photo © Kathy Hornsby

Directed by Tomás Gutiérrez Alea and Juan Carlos Tabío
Scene description: David and Diego's final embrace
Timecode for scene: 1:43:05 – 1:43:29

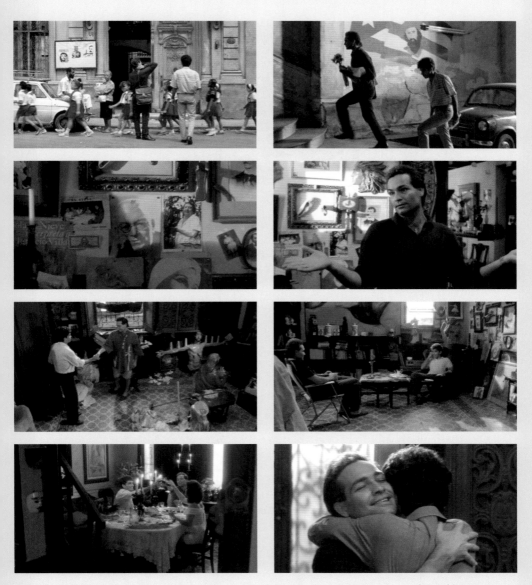

MADAGASCAR (1994)

LOCATION *Various exteriors and interiors in Centro Habana*

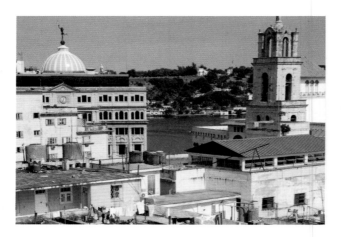

MADAGASCAR was made against all odds, during the summer of 1993. For capturing the existential uncertainty of that moment, the lowest point during Cuba's economic crisis, *Madagascar* is considered *the* film of this so-called 'Special Period'; one of the island's leading intellectual's, Ambrosio Fornet, deemed it to be 'an X-ray exposure of the prevailing state of our soul'. The young protagonist, Larita (Laura de la Uz), seeks to embrace the unknown, to simultaneously be 'here' and 'elsewhere'. In one scene, she stands with arms outstretched atop a multi-storey building in Havana. The editing reveals similar figures across the city, human cruciforms on *azoteas* (rooftops) interrupting the urban skyline. In an essay I wrote on the film shortly after its premiere, I likened these human forms to television antennae, awaiting distant signals, each one a medium for receiving and transmitting. Each stands alone, but they are connected by their shared experience, and by their joint invocation of the unknown, '*Madagascar, Madagascar.*' Through this mantra, Larita and the other young people seek to connect themselves with one another, to locate themselves vis-à-vis a nation undergoing rapid transition, and to reimagine their place in the world. For his poignant reflection of Cubans' reality during that difficult time, Pérez was named the Cuban film-maker of the 1990s. **⊷ Ann Marie Stock**

Photo © Kathy Hornsby

Directed by Fernando Pérez
Scene description: Larita on a rooftop, overlooking the expansive city
Timecode for scene: 0:38:28 - 0:39:45

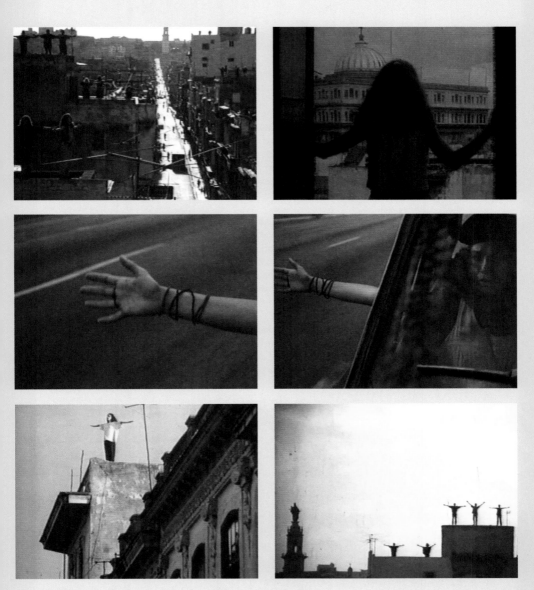

PARALLEL IMAGES

Cinemas and the City

Text by
PABLO
FORNET

FOR MORE THAN A CENTURY, the city of Havana and cinema have developed side-by-side. In 1897 the Frenchman Gabriel Veyre arrived in Havana from Mexico. This representative of the Casa Lumiére hosted, in an establishment on Prado Street, the first film-showing on the island. Havana was a city of 250,000 inhabitants at the time, a place where one barely noted the effects of the war against Spanish dominion that was waging in other regions of the country. The explosion of the battleship *Maine* in 1898 signalled the military intervention of the United States and, in 1902, the Republic was solemnly proclaimed. Shortly thereafter, large contingents of immigrants began arriving, as did the technological advances associated with modern industrial development: electricity, the automobile, telephone, radio, etc.

The projection of moving pictures extended to theatres near the Parque Central and immediately attracted ever-growing audiences. In 1906 the first venue designated explicitly for moving-picture exhibition was constructed on Monserrate Street; the structure, Actualidades, still exists today. In 1909 Cuba's fist open-air cinema, the Miramar Garden, introduced a moving-picture venue on the new seaside route, Paseo del Malecón. Not until

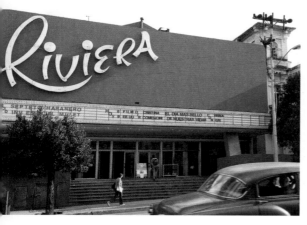

1927 was the first cinema constructed specifically for cinema; the Encanto on Neptuno Street boasted all the technical requirements for exhibiting motion pictures.

During the three decades of silent cinema, Havana had some sixty screening venues, the majority in the area between Monserrate and Galiano Streets. A few were located in other neighbourhoods around the city centre (from Galiano to Infanta); to the south, in the Cerro and Jesús del Monte districts; and to the west, in El Vedado (including one still in existence, the Trianón). In 1929 the Fausto, on Prado Street, ushered in a new era of commercial sound cinema with the premiere of *The Patriot* (1928), by Ernest Lubitsch.

By 1930 the population of Havana had reached a half-million inhabitants. The city centre was home to the major political and financial institutions as well as to commerce and culture. Yet, in terms of activity and population growth, it was the district of El Vedado that was gaining momentum, as well as the neighbourhoods to the south of the city. And the opening of a route to the new airport stimulated growth in this direction; the Reparto Lutgardita, a sector designed to include green space and industry, was constructed across from the airport.

From 1930 onward, major cinemas were built in the commercial district around Galiano and San Rafael Streets: Radiocine, Rex Cinema – first dedicated to showing documentaries and newsreels – and América (1941), a majestic art deco building that was the most lavish of its time. Two older venues were refurbished: the Fausto acquired a refined art deco look, and the Payret, adjacent to the Parque Central, was bought in 1942, demolished, rebuilt and reopened in 1950. This growth in the urban centre was paralleled by the creation of dozens of smaller 'cines de barrio' or neighbourhood cinemas around the periphery. While many were modest in size and design, a

few were lavish; the Lutgardita, with its exuberant design and pre-Columbian elements, was the most notable of those built in the outskirts.

By 1944 Havana was home to more than 100 cinemas. Development began to move toward the west of the city. In 1947, on the centrally-located corner of 23rd Avenue and L Street, the Warner was completed. Two years later, in the elegant residential district of Miramar, the Blanquita, opened; with nearly 7,000 seats it was deemed 'the grandest and most modern in the world'. It is the Vedado district, however, that was definitely the centre of entertainment and nightlife; there, between 1952 and 1957, three more modern cinemas opened their doors – the Rodi, La Rampa and the Acapulco.

By 1950, Havana's population reached 1 million inhabitants. The number of autos multiplied dramatically, and in 1955 the first drive-in cinema appeared, the Vento, with capacity for 800 cars. Two more drive-ins would follow: the Novia del Mediodía (with its lyrical name of 'Noontime Girlfriend') and Tarará. Each area of the city had its iconic venue for exhibiting major films: the Ambassador in Marianao, the Alameda in La Víbora, and the Carral in Guanabacoa. By the end of this decade, Havana had more than 140 cinemas with a total capacity of some 140,000 seats.

The construction of the tunnel under the bay opened a new urbanization horizon to the east. But with the triumph of the Revolution, the sites envisioned for upper-middle-class neighbourhoods were redirected to housing communities, a move consistent with the social interests of the time: La Habana del Este, at the beginning of the 1960s, and Alamar, in the mid-1970s. In the latter area, the XI Festival was constructed, the only theatre specifically designd for film to have been built in the past 50 years.

The year 1960 witnessed the nationalization of film distribution and production. For the next decade and a half, the number of films circulating increased as did the size of the viewing public. But by the mid-1970s, the deterioration of the venues and equipment led to an irreversible decline in filmgoing. In an attempt to 'save cinema' in the mid-1980s, a series of *video salas* were created, small video-screening spaces with an average of thirty seats; soon thereafter, however, it became evident that these were not viable and most were closed. In 1990 the capital's cinemas attracted barely one-fifth the number of spectators they had served only twenty years earlier.

The Havana of today appears to be a city frozen in time. Following its designation in 1982 as a UNESCO World Heritage Site, the historic zone of Old Havana has undergone a process of restoration that is devoted to rebuilding principal plazas and refurbishing major monuments. Outside this area, deterioration has continued to take its toll on residential dwellings, institutional buildings and public spaces. Paradoxically, it is the areas where the deterioration is most notable that the majority of present-day films are set; these images of the city have circulated most widely in recent years.

Today, with 2 million inhabitants, Havana has twenty functioning cinemas for a total capacity of 15,000 seats. In a race against time, an effort is being made to preserve them, but scarce resources make it difficult to save even the most emblematic venues, like those along the 'cinema circuit' on 23rd Street (La Rampa, Yara, Riviera, Chaplin, 23 y 12). The recent recuperation of the Infanta as a novel multiplex was favourably received by film fans. But few of the original cinemas remain in the old centre or in the *barrios*. Some have been transformed into small *video salas*, or are used for theatre performances and other kinds of shows. But the majority have disappeared, and with them an architectonic typology and a page in the city's history. Meanwhile, the recent move toward private enterprise has stimulated new tastes and transformed the urban landscape; increasingly makeshift stands offer 'pirated' films and posters advertising improvised projections of films in 3D. ✦

By 1950, Havana's population reached 1 million inhabitants. The number of autos multiplied dramatically, and in 1955 the first drive-in cinema appeared, the Vento, with capacity for 800 cars.

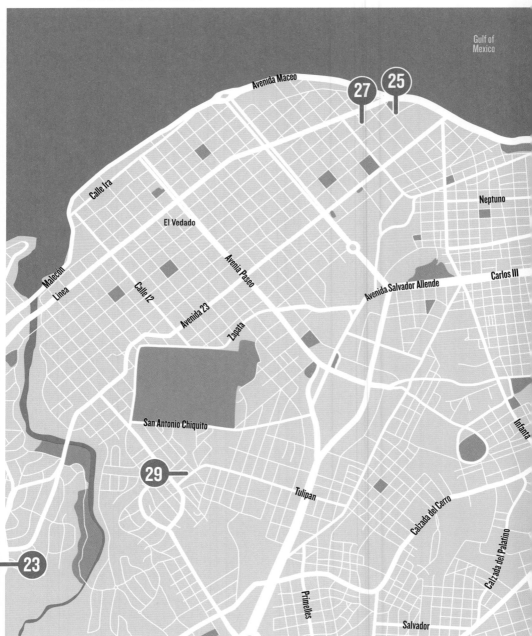

HAVANA LOCATIONS
SCENES 22-29

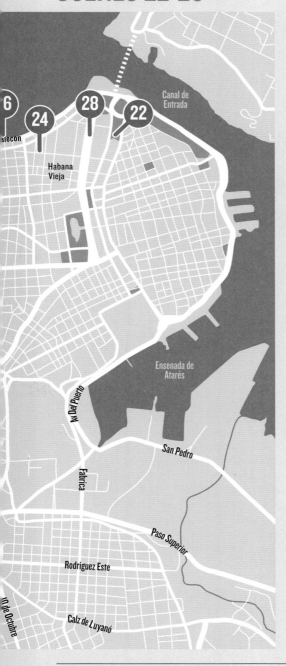

22.

THE LAST DAYS OF THE VICTIM/
LOS ÚLTIMOS DÍAS DE LA VÍCTIMA (1995)
March Park, in front of the Museum of the
Revolution (Museo de la Revolución)
page 66

23.

BUENA VISTA SOCIAL CLUB (1999)
4610 31st Street, Buena Vista
page 68

24.

BEFORE NIGHT FALLS/
ANTES QUE ANOCHEZCA (2001)
A ctually filmed in Veracruz Mexico but
depicted here as 162 Trocadero Street,
Barrio Colón
page 70

25.

HONEY FOR OSHUN/
MIEL PARA OSHUN (2001)
Hotel Nacional, 21st and O Streets, Vedado
page 72

26.

DIE ANOTHER DAY (2002)
Malecón (actually filmed in Cádiz, Spain)
page 74

27.

THE FIVE OBSTRUCTIONS/
DE FEM BENSPÆND (2003)
Havana (interiors)
page 76

28.

HAVANA SUITE/SUITE HABANA (2003)
Paseo del Prado, between Neptuno
and the Malecón
page 78

29.

DIRTY DANCING:HAVANA NIGHTS
(AKA DIRTY DANCING 2) (2004)
Represented here by El Gato Tuerto
nightclub on Calle O between 17 and 19
page 80

THE LAST DAYS OF THE VICTIM/
LOS ÚLTIMOS DÍAS DE LA VÍCTIMA (1995)

LOCATION *March Park, in front of the Museum of the Revolution (Museo de la Revolución)*

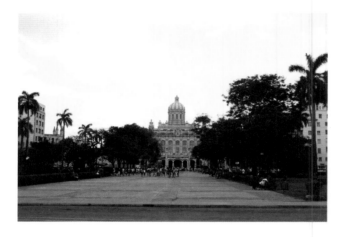

THIS MADE-FOR-TV MOVIE is a remake of an Argentine film noir, based on a novel by the same name. Unlike other versions set in Buenos Aires, this film takes Havana as its locale. The majority of the exterior action takes place in the 13th of March Park in front of the former Presidential Palace, now the Museum of the Revolution. The Park is named in honour of the university students who mounted an ill-fated attack on President Batista on 13 March 1957 resulting in the slaughter of most of them. The former presidential palace, symbolic of pre-revolutionary corruption, frequently appears in the background of these exterior shots, evoking the subtext of corruption in which the main character moves. That the bulk of the outdoor action occurs in the park named in honour of the slaughtered students prefigures the subsequent murder. The betrayal of the students is duplicated in the main character's own betrayal at the end of the film. The peaceful setting of the park – with its trees, ice cream vendors and children playing and flying kites – is belied by its tragic past, as well as by the murderous action afoot in the present, to which the other denizens of the park, excepting the victim and his assassin, are oblivious. Repeated returns to the park serve to bring together the various characters in a space that while seemingly innocent and free, is soaked with blood.**•»Richard Reitsma**

Photo © Google Earth

Directed by Bruno Gantillon
Scene description: First encounter in the park of four of the central protagonists
Timecode for scene: 0:36:36 – 0:37:00

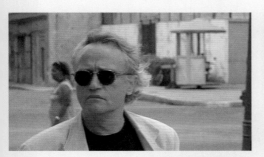

BUENA VISTA SOCIAL CLUB (1999)

LOCATION *4610 31st Street, Buena Vista*

THE BUENA VISTA SOCIAL CLUB no longer exists. 'Oh, that's long gone. It used to be there. It was in a house,' says an old man who Compay Segundo stops to ask for directions in Havana's busy Buena Vista neighbourhood. Another aged but sprightly passer-by intervenes – 'It was right there between 21st and 42nd' – and the neighbours promptly crowd around to opine: 'If you go this way, it's right there.' 'It's on 31st and 40th.' 'I used to dance there.' 'That house, the one with the painted door.' Wisely, director Wim Wenders leaves them wandering away from their idle present down lanes of unreliable memory and reinstates order, meaning and collective harmony by documenting Ry Cooder's assemblage of Cuba's most reviving, still surviving musical legends for recordings and concerts in Amsterdam and New York's Carnegie Hall. The album was a cultural phenomenon that made ubiquitous the forceful Cuban rhythms and the plaintive, tremulous voices that entwined them. Universal and yet still local, the Buena Vista Social Club was actually located on 31st Street between 46th and 48th in house number 4610. Sadly, since the documentary was released in 1998, Compay Segundo, Manuel Licea, Anga Díaz, Orlando López, Manuel Galbán, Rúben González, Ibrahim Ferrer and Pío Leyva have all passed on, meaning that the Buena Vista Social Club no longer exists. Again.➜**Rob Stone**

Directed by Wim Wenders
Scene description: Neighbourhood residents recall where
the Buena Vista Social Club might have been
Timecode for scene: 0:02:24 – 0:03:41

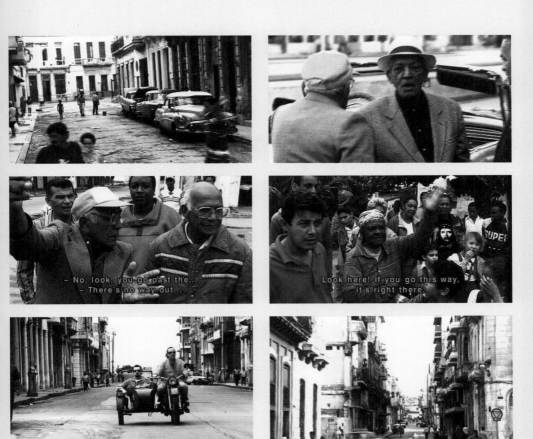

BEFORE NIGHT FALLS/
ANTES QUE ANOCHEZCA (2001)

LOCATION *Actually filmed in Veracruz Mexico but depicted here as 162 Trocadero Street, Barrio Colón*

BASED ON REINALDO ARENAS'S autobiography *Before Night Falls* (1992), this film follows his life from childhood through imprisonment and censorship to his escape and life in exile in the United States, where he lived his remaining years suffering from AIDS, finally committing suicide in 1990. While shot in Veracruz, Mexico, Havana is a principal character, from the Morro prison, the Forest Park of Havana (where he hid out in internal exile), to the Port of Mariel. A pivotal scene near the beginning of the film occurs in the home of José Lezama Lima, author of the neo-baroque novel *Paradiso* (1966). This interior scene in one of the sacred spaces of Cuban letters marks the passing of the torch from one generation of writers (Lezama Lima and Virgilio Piñera) to the next. It is the beginning of the literary education of the novelist as a young man (echoing Senel Paz a generation later), and his consequent counter-revolutionary position as an artist, symbolized by *Tres Tristes Tigres* (1966), a novel by the exiled writer Guillermo Cabrera Infante. The scene validates Arenas as a writer, but also clearly sets him up in opposition to the Revolution and to his state-sanctioned counterparts. In a country which vilified homosexuality until relatively recently, erasing such writers as Arenas, and whitewashing Lezama Lima and Piñera, the literary counter-revolution occurring inside the house marks Arenas's tragic literary trajectory. The paradoxical freedom of the interior contrasts with the oppression outside, a theme explored repeatedly in the film contrasting interiors with decaying exteriors. ➛*Richard Reitsma*

Photo © mdscop (panoramio)

Directed by Julian Schnabel
Scene description: Literary award ceremony at the home of José Lezama Lima
Timecode for scene: 0:28:02 – 0:33:00

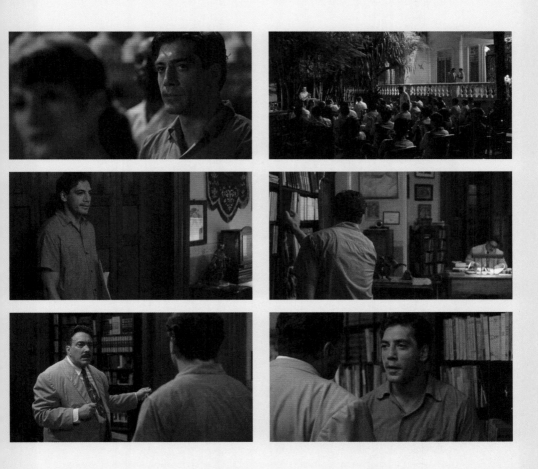

HONEY FOR OSHUN/
MIEL PARA OSHUN (2001)

LOCATION *Hotel Nacional, 21st and O Streets, Vedado*

THE FILM IS A LOVING HOMAGE to Cuba in all its decaying glory, a sumptuous tour, starting with the opening sequence of exiles arriving by plane, looking tearfully down upon the island they left years ago. The film follows the main character, who moved away from the island as a child. Thirty-two years later he returns as an adult in search of his mother, aided by his cousin and a taxi driver. Each is forced to plumb the past in order to better confront the disappointments of life in the present, both on and beyond the island. During the first third of the film, this search is contextualized by sweeping shots of Havana, initially from the vantage point of the luxury Hotel Nacional, and later from the walls of the Morro Fortress and the Malecón Sea Wall. The expectations, life experiences and the search for the past of the Cuban exile is manifest in his splendid lodgings and sweeping views of Havana, but his perceptions are grand, lacking detail. In contrast, his cousin spends her days working laboriously restoring a wall-painting in a colonial mansion in Old Havana. While one cousin views Havana with expansive (oft dismissive, academic) gestures, and the other focuses on minute detail, neither of them are able to see Havana, let alone Cuba or themselves, with any clarity. It takes an arduous journey through the contemporary Cuban countryside to Camagüey, breaking down the characters, to lead each to a place of understanding. **⊷Richard Reitsma**

Directed by Humberto Solás
Scene description: Various sites in Havana, including the Hotel Nacional, evoke nostalgia
Timecode for scene: 0:06:30 – 0:12:00

 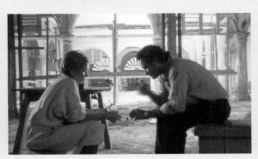

DIE ANOTHER DAY (2002)

Malecón (actually filmed in Cádiz, Spain)

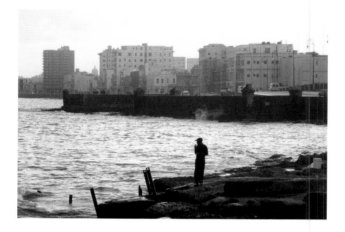

A BOLD FAN-THEORY holds that James Bond is not a man but a code name inhabited by successive agents, which is why he introduces himself so blatantly as 'Bond ... James Bond' wherever he goes, while at the same time retaining anonymity. Havana might also be a code name covering other locations that double for the secret city. Here 'Cuba ... Havana, Cuba' is the port of Cádiz on Spain's southern coast from where Columbus set sail to discover a trade route to India and discovered the Americas instead. Our not-so-secret agent (Pierce Brosnan) is on his way to North Korea and therefore as lost as Columbus as he strides away from the ocean on this mock-up Malecón as if he had just disembarked from the Santamaría. His landing on the island is performed against a backdrop of crammed-in customs and local colour. Never mind that this is 2002, the Cold War is over and the Special Period is ravaging the city, the extravagant cinematic shorthand of frolicking *Cubanos* wildly over-compensates for the pastel calm of Cádiz; it suggests an inadvertent yet delightfully subversive postcolonial return trip for the undercover islanders in which Cuba lays claim to Spain, its former imperial master. **⤙Rob Stone**

Directed by Lee Tamahori
Scene description: The secret agent on an imaginary Malecón
Timecode for scene: 0:30:01 – 0:30:21

THE FIVE OBSTRUCTIONS/
DE FEM BENSPÆND (2003)

LOCATION ⟩ *Havana (interiors)*

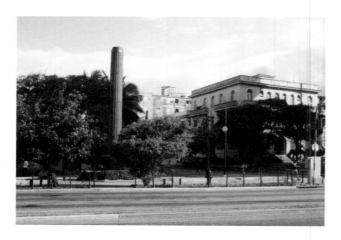

BY CHALLENGING HIS FRIEND and mentor Jørgen Leth to overcome
specific obstacles and remake his 1967 short film *The Perfect Human* five
times, Lars von Trier sets in motion a 'bromance' whose objective is both the
revival of Leth's creativity on film and an autopsy of his own. The first task
is a remake of the dancing part of the short film to be made in Cuba without
a set, with no shot longer than twelve frames (half a second) and in which
the questions posed in the first film are all answered. As if puppeteered into
embodying von Trier's anti-Americanism, Leth travels to Havana, where he
casts an *hombrón* and a young dancer who 'has nice tits'. Both staccato and
dreamlike, scored to 'Planting the Seed' (2002) by David Holmes, the resultant
short is rhythmic, stylish and sensual, turning the limitations against
themselves in its witty rendition of a funky modernist conceit. However,
although Leth finds solutions to the obstructions, his so-called 'answers' are
confounding: 'Why is he moving like that? Because women like it when
he moves like that.' Toplessness subtracts elegance and adds exploitative
cultural stereotyping with unwelcome shades of sexual tourism. And halving
Godard's dictum that film is truth 24 frames a second means that Leth's half-
second shots can only ever contain half-truths. Upon viewing it, 'silly' Lars is
unable to decide if he is bored or enchanted, so for the next challenge he sends
his friend to the red-light district of Bombay, Havana's opposite number, 'the
worst place in the world.' **◆Rob Stone**

Photo © Google Earth

Directed by Lars von Trier and Jørgen Leth
Scene description: Half-second images of a man smoking a cigar, a sleeping woman and Havana scenery
Timecode for scene: 0:10:25 – 0:15:26

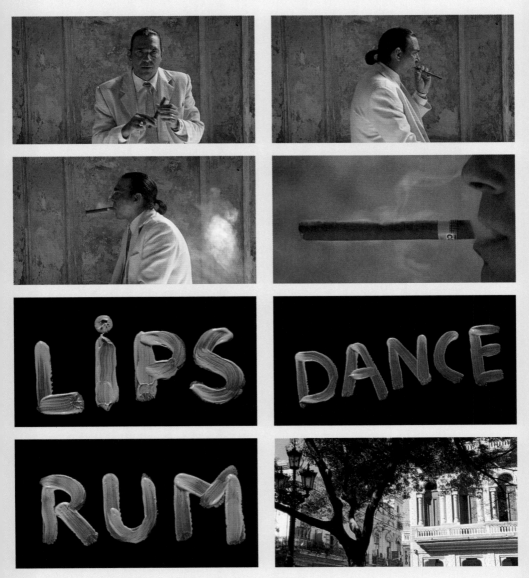

Images © 2003 Zentropa Real ApS/Almaz Film Productions/Panic Productions

HAVANA SUITE/SUITE HABANA (2003)

LOCATION *Paseo del Prado, between Neptuno and the Malecón*

HAVANA SUITE harmonizes the beats of the city and its people throughout a regular Havana day. A moving documentary whose protagonists include a young boy with Down's syndrome (Francisquito), a labourer who at dusk transforms into someone else altogether, a musician, an elderly peanut vendor (Amanda), a doctor who makes his living as a clown, a teenage dancer who is working to fix up his house (Ernesto) ... The silence and dignity of the characters are juxtaposed with the bustle and decay of the city. The city itself – with its diversity of exteriors and interior environments – is, along with its inhabitants, the principal protagonist. While the John Lennon statue in El Vedado's park marks the rhythms of the day and of the absurd, the imperturbable Morro lighthouse orients travellers and passers-by. At dusk, the paths of Francisquito and Amanda cross: he walks down the Paseo de Prado with his father and buys from her a paper cone filled with peanuts. Later, in a touching scene, father and son make shadow puppets with their fingers, while in another part of the city, the dancer, Ernesto, tries to hail a taxi on his way to a ballet performance. The contagious happiness of Francisquito poses a stark contrast to the sadness expressed on Amanda's face: he dreams of climbing up to high places; she, on the other hand, no longer has any dreams.

✦Pablo Fornet

Photo © Google Earth

Directed by Fernando Pérez
Scene description: Francisquito and his father interrupt their stroll to buy
peanuts from a street vendor
Timecode for scene: 0:44:18 – 0:45:08

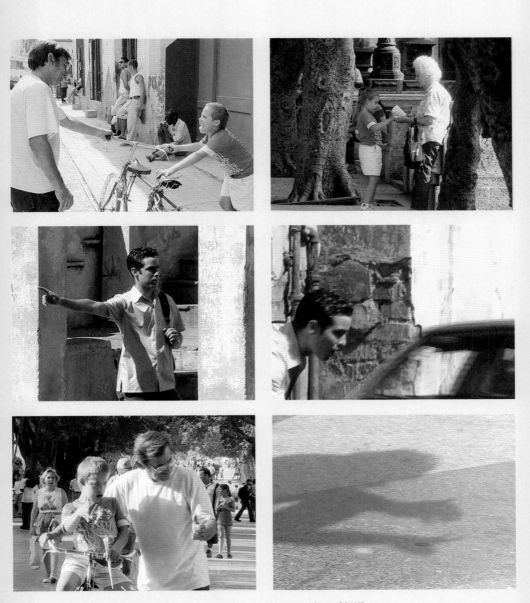

Images © 2003 Wanda Vision/Instituto Cubano del Arte e Industria Cinematográficos (ICAIC)

DIRTY DANCING: HAVANA NIGHTS (AKA DIRTY DANCING 2) (2004)

LOCATION > *Nightclub named El Gato Tuerto (The One-Eyed Cat)*

DEAR DIARY, I shall never forget the events of New Year's Eve in Havana 1958–59 when I learned to dance and fell in love even though it was like, really really noisy for some reason ... Katey Miller (Romola Garai) is a straight-A student whose father, a Ford executive, gets posted to Havana. There a Zen master disguised as this really cute boy called Javier (Diego Luna) proves keen to teach her that dancing is 'about being exactly who you want to be in that moment'. Despite wanting to be in a much better film, Garai and Luna practice in the hotel which is seemingly haunted by the ghost of Patrick Swayze (or his career) and eventually bring the house down at both a Latin Ballroom Contest in the Palace Club for expats (invented) and La Rosa Negra nightclub where the natives go wild (dreamed up, although the nightclub El Gato Tuerto does a good job of comforting the frustrated). Garai is game, Luna is leaden and Havana is postcard-pretty. Javier is distracted by the incipient Revolution but Katey is having the time of her tiny life. However, come the Revolution and Katey's correlated deflowering, it is unclear whether this all-American girl is liberated via her seduction by this opportunistic revolutionary or, more like Batista and his American allies, just screwed.
•❖Rob Stone

Directed by Guy Ferland
Scene description: Katey and Javier dance together against a vibrant nightclub backdrop
Timecode for scene:0:19:24 – 0:25:42

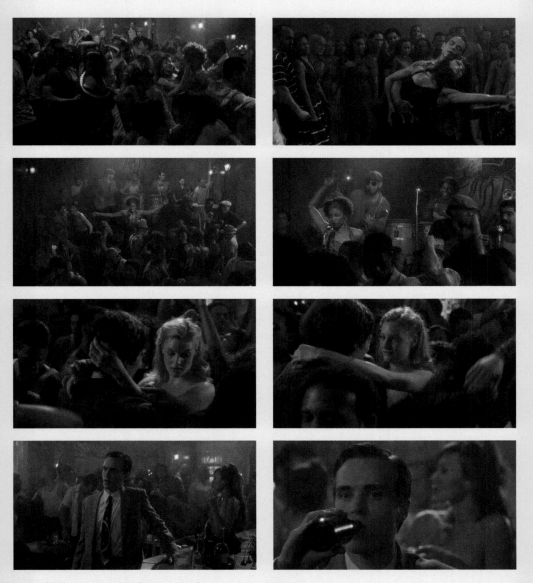

Images © 2004 Lions Gate Films/Miramax Films/Lawrence Bender Productions

NOW

Urban Ethnographies

Text by
SUSAN
LORD

HAVANA IN THE 1960S was perhaps the most dynamic city in the world, attracting thousands of *campesinos*, political tourists, solidarity brigades, Black Panthers, new Soviet residents; abandoned property was then redistributed; monuments to imperialism were destroyed; banks were turned into hospitals; hotels into headquarters of the newly formed government; graffiti of literacy campaigns, rebel youth and 'the new man' became the new advertising; Havana hosted the most significant international political and cultural events of the era; and the notorious UMAP camps for the 'misplaced elements' were formed. A host of radical film-makers from around the world – Agnes Varda, Chris Marker, Mijail Kalatozov, Tony Richardson, Joris Ivens, Vladimir Cech, and more – went to Havana, Algiers, Montreal, Harlem, to film their new 'spaces of hope' in the 1960s.

A new cinematography was needed to bring the intensity of this new city to the screen. The hothouse of Havana and its Film Institute

(ICAIC) interpreted Free Cinema, *cinéma-vérité*, experimental film, *nouvelle vague* and consciousness-raising reflexive documentary with the decolonial cultural agenda of the Revolution. Tomás Gutiérrez Alea knew already in 1960 during the shooting of *Historias de la Revolución/ Histories of the Revolution* that the photographic style created for him by Italian neo-realist cinematographers did not respond to his desire for a more dynamic image, looser mise-en-scène, with photography of high contrasts, harsh, dramatic. Alea, of course, goes on to make *the* city film of the 1960s, and in *Memorias del subdesarrollo/ Memories of Underdevelopment* (1968) we see this fluidity of the street poised against the formalism that expresses Sergio's confinement. But in *Asamblea general/General Assembly* (1960), the documentary about Fidel's address of the First Declaration of Havana in the Plaza of the Revolution, Alea practises what becomes a sustaining Cuban contribution to documentary. Engaging with Free Cinema and *cinema-vérité*, his camera seems to touch the faces of the new citizen one by one rather than as a single mass before a leader. This mode influences work of the 1960s and 1970s; it is visible in the works of Manuel Octavio Gómez and Santiago Álvarez, and the infamous *PM* (Sabá Cabrera Infante and Orlando Jiménez Leal, 1961); the documentaries of Nicolás Guillén Landrián and Sara Gómez, however, exhibit it most powerfully.

Whereas ICAIC's mandate of nation-building focused on decolonizing the history of the nation, a handful of film-makers focused on the streets, neighbourhoods and suburbs of their Havana – NOW. One vehicle for these visions was the Popular Encyclopedia series (1961–63); intended as a didactic educational device, as both a training

ground and an experimental studio, this series helped film-makers – including Humberto Solás, Octavio Cortazar and Oscar Valdés – stretch their practices. The Popular Encyclopedia series saw Sara Gómez's *Solar Habanero/Havana Tenement*, *Plaza Vieja/Old Square,* and *Historia de la piratería/ History of Piracy* and *El solar/The Tenement*. Within the themes and pro-filmic space of these four works made in 1962, Gómez at age nineteen began her short but intensely committed project of filming the 'popular' realities on the margins of the Revolution's Triumph.

She and Nicolás Guillén Landrián are the two urban ethnographers of the period who, with strikingly different styles and geographies, focused on the ongoing issues related to poverty, race, gender, machismo, boredom, youth, alienation, prostitution, housing and popular music. These new ethnographers were dedicated to documenting the spaces invisible to the eye of imperialism in the pre-1959 period and troubling to the project of 'the new man'. Throughout the 1960s and early 1970s they made films where the city is a character pulling the camera, creating new movements and fluidities and belongings for the device – and thus for film viewers. After her time with the Encyclopedia, Gómez went on to make a series of documentaries, each strikingly different in style and each stretching the limits of documentary conventions. This experimentation, while certainly participating in the New Cuban Cinema's creative revolution, signifies a response to those elements of history, memory and everyday life that are frozen out of the frame of dominant narratives of nation and subjectivity. Whether the subject matter concerns the local cultural and political critiques of national work programs (*Sobre horas extras y trabajo voluntario/Overtime Hours and Volunteer Work*, 1973) and election processes (*Poder local/Local Power*, 1970) or the maternal lines and race politics within a family (*Guanabacoa: Cronica de mi familia/Guanabacoa: Chronicle of My Family*, 1966), the films consistently bring to the frame marginal identities. Her attention is on the complex dynamic of urban life. In all of her films, windows and thresholds or doorways speak volumes – they are spaces of emergence. They are interior frames that function to mediate or create a density of mediation by which to literally 'see' the emergence of a new subjectivity.

Nicolás Guillén Landrián ('Nicolasito') – nephew of the great Cuban national poet Nicolás Guillén – joined the ICAIC in 1961. He went on to make some of the most formally inventive and socially insightful films of the first decade of ICAIC. Trained as a visual artist, he was deeply informed by Cuban conceptual photography and the experimentalism of ICAIC; and in *Reportaje* (1966), *Coffea Arábiga* (1968) and *Desde La Habana 1969 ¡Recordar!* (*Remembering Havana*, 1969), we see his connections to the montage and emulsion experiments of his American counterparts. Like Sara Gómez, Nicolasito was deeply interested in the contradictions between the Revolution's dreams and the geographical and social margins. His first significant film, *En un barrio viejo* (*In an Old Neighborhood*, 1963), is exemplary of the new urban ethnography. Whether making a film about how to make a house or a film about the history of coffee, Nicolás Guillén Landrián presents us with an aesthetic density that matches the complexity of contemporary life experienced by the citizen. These layers of images – emulsion and graphic-design experiments, popular US culture, state propaganda – and sound experiments form a new kind of ethnographic encounter. Sara Gómez and Nicolás Guillén Landrián open the frame to a citizen and a practice that insists 'No es el fin' ('It isn't the end'). And indeed it was not. Their work would continue to inspire and inform Cuba's film-makers, propelling them into the twenty-first century. ✢

Whereas ICAIC's mandate of nation-building focused on decolonizing the history of the nation, a handful of film-makers focused on the streets, neighbourhoods and suburbs of their Havana – NOW.

LOCATIONS MAP

HAVANA

maps are only to be taken as approximates

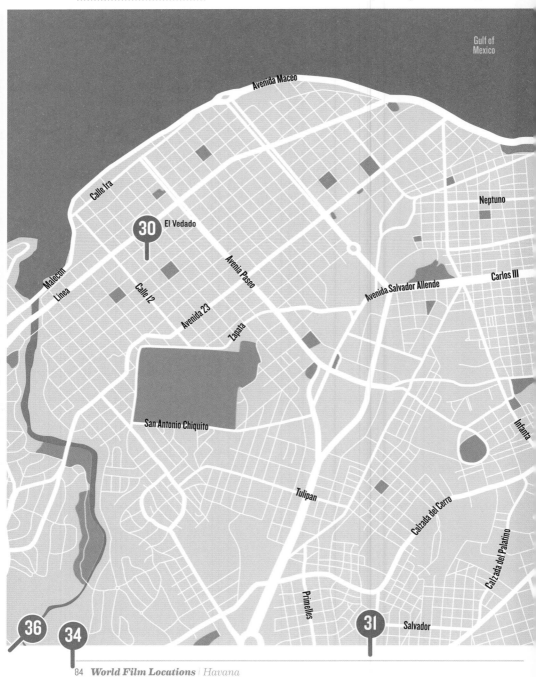

N

Gulf of Mexico

Avenida Maceo

Calle 1ra

30 El Vedado

Malecón

Linea

Calle 12

Avenida 23

Avenia Paseo

Zapata

San Antonio Chiquito

Neptuno

Avenida Salvador Allende

Carlos III

Infanta

Tulipan

Calzada del Cerro

Calzada del Palatino

Primelles

36 **34**

31 Salvador

HAVANA LOCATIONS
SCENES 30-36

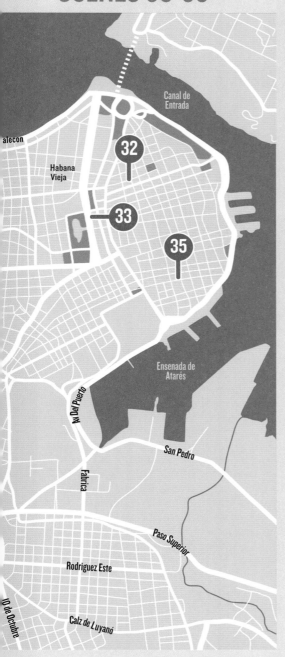

30.
HAVANA BLUES/HABANA BLUES (2005)
Corner of 13th and 8th, Vedado
page 86

31.
VIVA CUBA (2005)
Lenin Park, La Presa Highway,
Habana del Este
page 88

32.
THE AWKWARD AGE/
LA EDAD DE LA PESETA (2006)
Bacardí Building, 261 Monserrate between
San Juan de Dios and Empedrado, La
Habana Vieja
page 90

33.
SONS OF CUBA (2009)
Havana Boxing Academy, noted on map as
Sala Polivalente Kid Chocolate on Paseo de
Martí between Obrapia and Teniente Rey
page 92

34.
LONG DISTANCE/LARGA DISTANCIA (2010)
José Martí International Airport, Terminal 3
page 94

35.
JOSÉ MARTÍ:THE EYE OF THE CANARY/
JOSÉ MARTÍ:EL OJO DEL CANARIO (2010)
Teatro Villanueva, on La Merced Street,
in what is now Old Havana
page 96

36.
CHICO & RITA (2010)
The Tropicana, Playa, Zona Marianao
page 98

HAVANA BLUES/HABANA BLUES (2005)

LOCATION *Corner of 13th and 8th, Vedado*

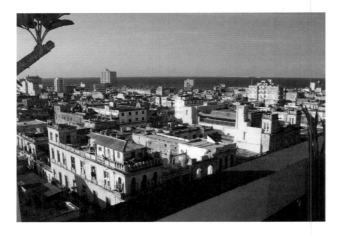

THE CITY OF HAVANA is at the same time the protagonist and the missing element of *Havana Blues* since most of the scenes were shot indoors and in Camagüey. Yet, powerful snapshots of the streets, roofs and inhabitants of the capital city give a sense that Havana is a mirage ready to vanish. The film tracks two best friends and musicians, Ruy and Tito, who are trying to walk in the footsteps of the iconic band Habana Abierta. The blues provides the musical fusion to illustrate the visual presence/absence of Havana city and to tell the story of its ambivalence and contradictions: present but soon to be absent, opening up but nevertheless closed, genuine but exoticized. This ambivalence is best represented on a rooftop terrace, *la azotea*, which has been an emblem of the city and an element of its mythification since the Revolution, in literature as well as in cinema. After a close-up on a tearful Caridad (Ruy's wife), talking on the phone from the family house's *azotea*, the camera brings us, from one rooftop to another, to a crowded and sunny terrace where the leader of Habana Abierta performs his hit song 'Sedúceme'/'Seduce me' (2002). The intimate, melodramatic and recluse scene (probably not shot in Cuba's capital) shifts to an open-air, sunny and beautiful postcard of Havana from the rooftops. The opened Havana is indeed visible as an object of desire and transaction, '*sedúceme*, one platform – but not the whole city – selling itself to tourism and global music as an exotic and erotic place'.
➙*Fabienne Viala*

Photo © Noah Montague

Directed by Benito Zambrano
Scene description: *A panoramic view of the city from one of Havana's many rooftop locales*
Timecode for scene: *0:28:24 – 0:29:41*

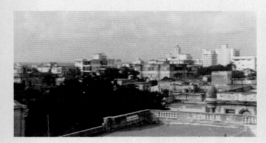 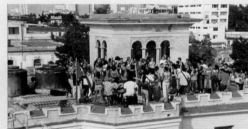

VIVA CUBA (2005)

LOCATION *Lenin Park, La Presa Highway, Habana del Este*

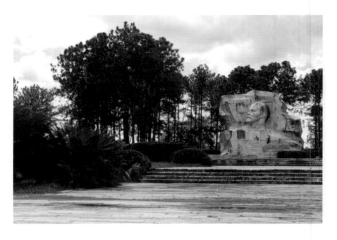

VIVA CUBA is a road movie in which two 11-year-olds escape from their homes in Havana and head towards the island's easternmost point. What ensues is a series of adventures – sometimes amusing, sometimes poignant – permitting a glimpse into life in present-day Cuba. It is a time of tensions between rootedness and mobility, past and future, national and transnational. The protagonists' physical journey invites a reflection on the concept of Cuban identity. In this era characterized by movement and migration, Cuban-ness has less to do with one's presence on the island or ideological position than with one's relationships. What defines the films' protagonists is their emotional connectedness. Locating oneself, then, isn't about being 'for' or 'against', or living 'here' or 'there'. Instead, it's about establishing relationships. In a sequence artfully filmed by Alejandro Pérez and thoughtfully edited by Angélica Salvador, Malú (Malú Tarrau) and Jorgito (Jorge Miló) kneel against an expansive sky in Lenin Park, sharing the frame with a single solitary tree. Cut to a close-up of their hands burying the tin box holding their pledge of friendship, and then to a shot depicting the two children and the container from above. The Cuban soil in which the nearby tree grows is not what nurtures them; rather, they are sustained by their connection to one another, rooted by their mutual devotion and lifelong solidarity. ➥*Ann Marie Stock*

Photo © FDBK (wikimedia commons)

Directed by Juan Carlos Cremata
Scene description: Malú and Jorgito pledge their friendship in Lenin Park
Timecode for scene: 0:10:57 – 0:11:40

THE AWKWARD AGE/
LA EDAD DE LA PESETA (2006)

Bacardí Building, 261 Monserrate between San Juan de Dios and Empedrado, La Habana Vieja

1958 IS LIKELY THE MOST recreated year in the Cuban cinema of recent decades. After five years away, Alicia (Susana Tejera) returns to Havana to restart her life in the city. She arrives with Samuel, her 10-year-old son (Iván Carreira) who is living 'the age of the peseta', or his pre-adolescent years. Their arrival at the home of Violeta, Alicia's mother (Mercedes Sampietro), generates tensions between the women. Grandmother and grandson become close, a relationship that evokes between them a certain collusion. Violeta is a portrait photographer; she retouches the photos – because 'reality always needs it' – and Samuel delivers them to their recipients. Alicia feels she must look for work, and eventually arranges an interview in the Bacardí building, the emblematic Havana landmark constructed in 1930. We see its impressive facade and its dazzling interiors: floors, elevator, decorations ... But the moral precepts of the time work against Alicia, a divorced single mother, so her efforts ultimately prove to be unfruitful. The scene ends as Alicia enters the art deco cinema América, where she meets Ramón (José Ángel Egido). Unhappy about his mother's developing relationship with Ramón, Samuel lives out an idealistic love of his own that will transform his life. Things seem to have returned to normal for the family, but their paths diverge yet again when the Revolution triumphs in 1959. ••*Pablo Fornet*

Directed by Pavel Giroud
Scene description: Alicia goes to a job interview
Timecode for scene:0:14:20 – 0:16:35

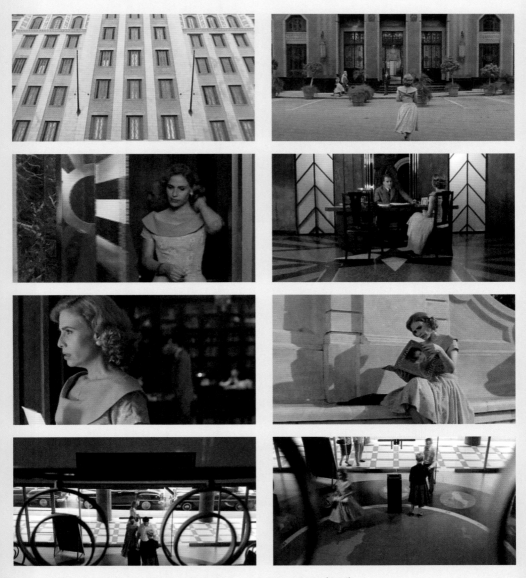

SONS OF CUBA (2009)

LOCATION

Havana Boxing Academy, noted on map as Sala Polivalente Kid Chocolate on Paseo de Martí between Obrapia and Teniente Rey

AMIDST A FOREBODING BACKDROP of gusty winds and choppy waves, the voice of Fidel Castro proclaims, 'The Revolution must concentrate on sports. On the frontline of sports the Revolution will advance!' *Sons of Cuba* opens with this powerful confluence of spoken word and visual imagery. Havana's sky is dark; sinister clouds threaten overhead. Cuba's leader pronounces his nation's fight for supremacy in sports – specifically boxing – and a streak of lightning cuts across the screen. As the currents of competition and national expectation swirl into frenzy, the young athletes of the Havana Boxing Academy sleep soundly in their beds, unaware of the mounting pressure. *Sons of Cuba* tells their story, introducing a host of talented young boxers who approach the sport with focus and exuberance. Frayed gloves in hand, they carry Havana's boxing expectations upon their shoulders, a weighty burden in a country where boxing pre-eminence is not only a matter of entertainment but of ideological pride. Despite the maturity with which they approach the sport, the boys retain all the characteristics of youth. In a touching scene, they frolic about their room during a rare moment of leisure, dancing between the utilitarian bunk beds, playing cards in the corner, singing with friends. As the boys dash about amidst a chorus of laughter, the coaches, in marked contrast, watch over them with serious expressions. Cuba's national boxing championship is fast approaching and the boys will soon don their determined game faces, but until then, the camera frames their unadulterated smiles of youth. **Emma Rodvien**

Photo © Google Earth

Directed by Andrew Lang
Scene description: Boys sleeping in the Boxing Academy as a storm brews outside
Timecode for scene: 0:18:00 – 0:20:00

Images © 2009 Trinamite Productions/Windfall Films

LONG DISTANCE/LARGA DISTANCIA (2010)

LOCATION José Martí International Airport, Terminal 3

'I ALWAYS IMAGINED this film as a result of human and conceptual longing,' notes the director, who deems his first feature to be a story 'of human uprooting, missed encounters, and nostalgia evoked from within'. This film explores the experiences of Cubans who remain on the island after families and friends have dispersed. The protagonist, Ana (superbly rendered by Zulema Clares), plans a reunion with friends to celebrate her birthday. What becomes clear as the narrative develops – from the high-design black-and-white interior of Ana's flat, the employment of distinct colour palettes for each character, and the persistent movement between past and present – is that this gathering is more imagined than real. Past merges with present in *Long Distance*, and fiction conventions blend with documentary techniques. At one point Ana is depicted in José Martí Airport's International Terminal 3; distinctive with its high ceilings and abundant light, the structure was constructed in the late 1990s to accommodate growing numbers of tourists from Europe, Canada and Latin America. Ana's silhouette, framed from behind, is visible against the jetway entrance; significantly she occupies that liminal space between here and there, between origin and destination. *Long Distance* is less intent on capturing a particular time and place than on probing the pain of separation, the prevalence of human longing, and the need for connectedness. The film's final dedication – 'to those who left ... and to those who stayed' – invites a reflection on the importance of preserving relationships and promoting solidarity as well as on the persistence of memory. ⟿ ***Ann Marie Stock***

Photo © Happypepe (wikimedia commons)

Directed by Esteban Insausti
Scene description: Ana at the José Martí International Airport
Timecode for scene: 1:23:26 – 1:26:01

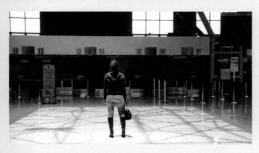

JOSÉ MARTÍ: THE EYE OF THE CANARY/
JOSÉ MARTÍ: EL OJO DEL CANARIO (2010)

LOCATION *Teatro Villanueva, on La Merced Street, in what is now Old Havana*

HAVANA ... baroque, neoclassic, proslavery; architecture and ways of life that transformed the city into one of the most eclectic of the Spanish-speaking world and one of the most European of Latin America in the nineteenth century. The city where Fernando Pérez's film takes place. This prestigious film director presents a Havana of narrow dusty streets filled with passers-by, slaves, vendors and merchants; with old houses and buildings, with clay bricks and stone slabs, surrounded by a wall. That is where Cuba's national hero, José Martí Pérez, was born (b.1853–d.1895). The film deals with his childhood and adolescence. In a metropolitan atmosphere, where the film's visual and urban metaphors project an atmosphere at once oppressed and oppressing, Martí develops a historical consciousness that will lead to social reform in his country. An allegorical scene tracing this intellectual process is that which recreates the public repression against the advocates of Cuban emancipation that occurred on 22 January 1869 in the Teatro Villanueva. José Martí was there that night. The sequence shows a wooden theatre holding some 1,300 people (located on La Merced Street, in the area now known as Old Havana). At one point during the show, chaos erupts. Shots, disorder, arrests, deaths ... all this occurs in a scene of great drama and strong emotions. We are reminded of one of the most famous places in the city as well as of the construction of the emerging nation. •• *Antonio A. Pitaluga*

Photo © Google Earth

Directed by Fernando Pérez
Scene description: Nationalist rebellion in the Teatro Villanueva in Old Havana
Timecode for scene: 1:11:55 – 1:14:25

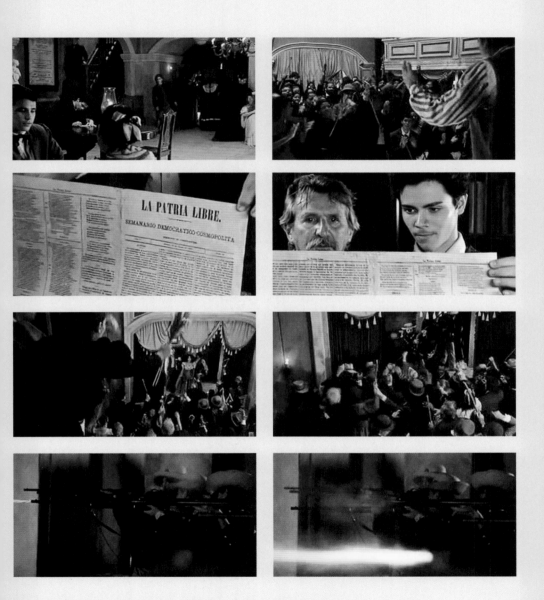

CHICO & RITA (2010)

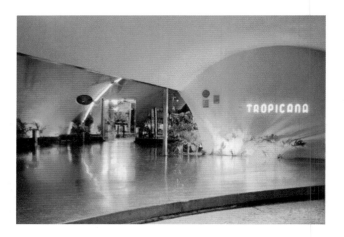

BEHIND THE ODDLY unsatisfying romance, the never more animated Havana of 1948 was recreated so affectionately from archive photographs that the film's directors frequently boast of teary-eyed Cuban audiences congratulating them on so vividly reviving their past. Told in flashback from a dingy and decaying apartment, this Havana is remembered, imagined and imagined as remembered to render pre-reality Cuba in a coloured-in kaleidoscope of romantic possibilities. The flowing, curvaceous animation describes a tryst between a green-eyed *mulatta* who torch-sings and the hottest piano-player in Havana and is bathed in Cuban rhythms and classic songs such as 'Bésame mucho' ('Kiss me a Lot,' Consuelo Velazquez, 1940) and 'Sabor a mi' ('Be True to Me,' Alvaro Carrillo, 1959). The period panorama features appearances by the Tropicana nightclub, Charlie Parker, the Hotel Nacional, Dizzy Gillespie and Cadena Azul as it unpeels layers of cute, charming, sensual and erotic cartooning before jazz and bebop is denounced as 'the music of the enemy' and the couple drawn together by music and pencils is separated by the erasure of decades prior to a sad little ending in Las Vegas that makes one miss the Tropicana. Ah, the Tropicana! 'The hottest nightclub in Havana!' Here a fluorescent cathedral of starlight and orchestral pizzazz where Chico, fizzing like a *mojito*, first saw Rita sing, smooth as a pina colada. It was love or something like it, swiftly consummated by the outlines of two pervasive but ill-fated ideas: hers to triumph in America, his to revolutionize music in pre-revolutionary Cuba. **⬧Rob Stone**

Photo © Emma Rodvien

Directed by Fernando Trueba, Tono Errando and Javier Mariscal
Scene description: Chico plays piano at The Tropicana while Rita sits at the bar
Timecode for scene: 0:09:28 – 0:13:42

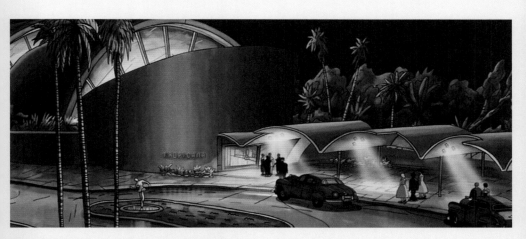

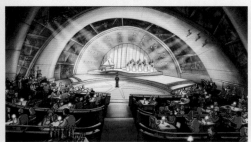

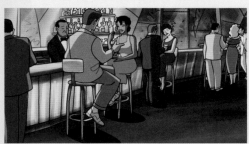

Images © 2010 Isle of Man Film/Estudio Mariscal/Fernando Trueba Producciones Cinematográficas

'STREET FILM-MAKERS' OPEN NEW ROADS

Text by ANN MARIE STOCK

A YOUNG HAVANA ARTIST, passionate about animation. In the corner of his bedroom, on a personal computer with 'hacked' CGI programs, he creates animated shorts. Another twenty-something *Habanero*, with a camera hanging on a strap around his neck, pedals around the city to find subjects to interview for his documentary. A third young media maker, a student, creates a thesis project so nuanced it has been interpreted as both a testament to creativity the Revolution has fostered, and a denouncement of the limitations it has imposed. All of these works have been made recently by audio-visual artists not yet 30 years old; and all have garnered prizes at home and beyond. These three film-makers – Ernesto Piña Rodríguez, Esteban Insausti and Laimir Fano – belong to a new generation of audio-visual artists. Like previous generations of Cuban cineastes, these new artists are wielding cameras to construct their nation. Unlike their industry predecessors, however, many of these artists work not within the National Film Institute (ICAIC), but rather on the streets. Filming from the margins, they focus on persistent problems and question long-held truths. As they document their rapidly changing reality, they explore what it means to be 'Cuban'

in the twenty-first century. This new generation of 'Street Film-makers' is adept at employing emerging technologies, capable of establishing alliances in and beyond Cuba, and prepared to *resolver* or make do.

The 1990s was a time of dramatic transformation for Cuba. With the collapse of the Soviet Union, the island nation plummeted into a full-scale crisis. This 'Special Period' left Cubans struggling – both to make ends meet and to reckon with an uncertain future. Predictably, the resource-intensive enterprise of film-making felt the impact. It was during this time that a new generation of audio-visual artists emerged. Intent on making movies, but lacking opportunities within the industry, these 'street film-makers' set out to seek funding, establish contacts and procure equipment. Out of necessity, working with limited budgets and without industry infrastructure, this generation became remarkable problem-solvers. And their efforts revolutionized the ways in which films would be made in Cuba and marketed the world over from that time onward.

Works created in this style – whether categorized as fiction, experimental or animation – share common features: all have relied on new technologies for their creation, oftentimes in conjunction with traditional approaches; all have been financed with low or no budgets; all have benefited from local-local and local-global partnerships; and all reveal a commitment to experimentation and innovation. Most significantly, these films have all been made by audio-visual artists adept at *resolviendo* or making do. Working on their own, they combined footage filmed with a variety of cameras, filmed night scenes during the day, coloured on and scraped away the celluloid, and actually invented new techniques every step of the way. They also devised marketing strategies and participated in circulating their films. Impatient and passionate, propelled by perseverance and an entrepreneurial spirit, these artists opened new avenues for creating and disseminating their work.

Seeing themselves as active agents in charting their future and that of their nation, these creators

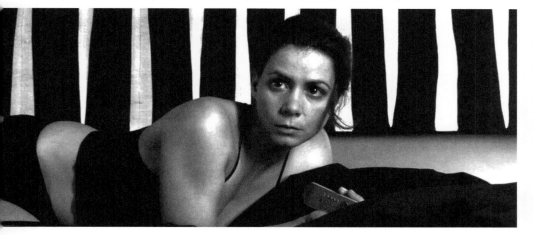

ask pointed questions, pose challenges and provoke debate. They are comfortable using celluloid, video and digital media, sometimes combining all of them in a single project. Many are involved in some way with the National Film Institute (ICAIC), but virtually all carry out non-industry projects as well. Whether working within or outside the industry, they succeed at mobilizing contacts and capital from the island and beyond.

Films produced by this new generation vary greatly – in style and subject matter and approach. Among them are included features, animation, documentaries and video clips. Some film-makers mine cultural forms and histories to create their work. Ernesto Piña Rodríguez recasts Japanese *manga*. In his *Eme-5/M-5* (2004), Voltus 5 spaceship is transformed into the distinctly Cuban *camellos*, a semi-trailer/bus. Waldo Ramírez integrates Queen's 'Bohemian Rhapsody' into his short titled *Freddy o el sueño de Noel/Freddy or Noel's Dream* (2003). The crescendo of the soundtrack accompanies the fantasy of a young boy.

Some audio-visual artists reflect on the creative process. In *Habanaceres/Havana Dawns* (2001), Luis Leonel León interviews four of Cuba's leading culture workers whose collective impressions illuminate the changing role of artists. In *Zona de silencio/Zone of Silence* (2007) Karel Ducasse

> **Films produced by this generation are decidedly diverse, but one concern prevails – the plight of islanders as they struggle to get by during difficult times.**

features four artists who comment candidly on their varied takes on censorship in Cuba.

Other projects employ humour and satire. In *Utopía* (2004), Arturo Infante critiques his nation's cultural literacy agenda with beer-drinking domino-playing men and gum-chewing nail-painting women debating the finer points of Italian opera and baroque aesthetics. Eduardo del Llano has created an entire series poking fun at Cuban reality.

Films produced by this generation are decidedly diverse, but one concern prevails – the plight of islanders as they struggle to get by during difficult times. These film-makers tackle subjects once considered taboo in Cuba – mental illness, domestic violence, prostitution, homosexuality, emigration, censorship, drug use and abuse, housing shortages, and so on. They reveal inconsistencies between official policies and actual practices. And yet, these artists generally do not set out to undermine revolutionary aims and accomplishments. Instead, they seek to identify problems in their midst so as to foster awareness and encounter solutions.

Many 'Street Film-makers' focus on the island's disenfranchised sectors. In doing so, they employ their creativity to promote tolerance and effect social justice. The Cuban actor-director, Jorge Perrugoría, underscored this tendency in a recent interview:

I think Cuban film has a commitment with society, a commitment that is very visible in all kinds of Cuban art. It's the commitment of artists to not only entertain but also to make people think, reflect, and question reality – which is the only way of changing or improving it. ✛

LOCATIONS MAP

HAVANA

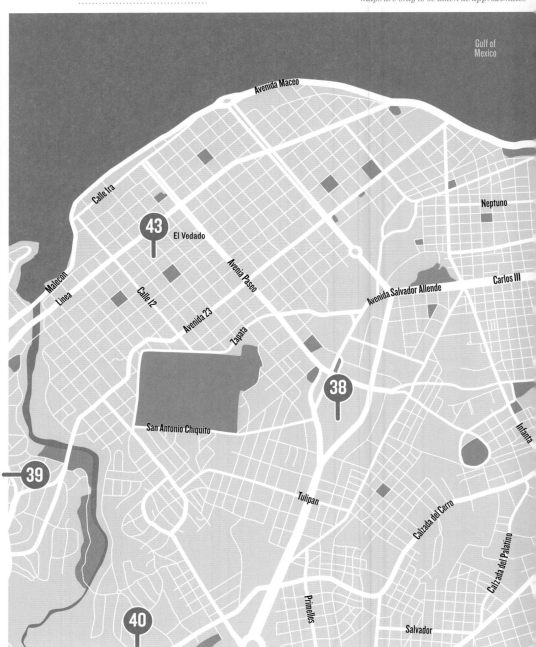

Gulf of Mexico

Avenida Maceo

Calle Ira

43 El Vedado

Neptuno

Avenia Paseo

Malecón

Linea

Calle 12

Avenida 23

Avenida Salvador Allende

Carlos III

Zapata

38

San Antonio Chiquito

Infanta

39

Tulipan

Calzada del Cerro

Calzada del Palatino

40

Primelles

Salvador

HAVANA LOCATIONS
SCENES 37-43

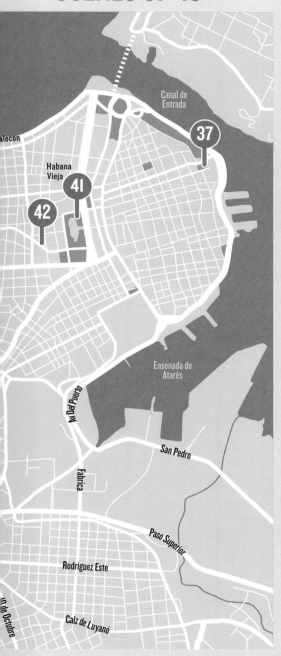

FABLE/FÁBULA (2011)

Rubén Martínez Villena Public Library, Obispo 59, La Habana Vieja

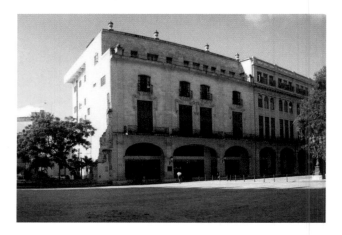

LÉSTER HAMLET'S homoerotic love story begins by telling the audience that the film is a 'Short story with didactic intent expressed with a moral ending, and in which animals talk'. For this reason the place that the central characters meet, the Rubén Martínez Villena Public Library in Old Havana, is the perfect setting. Place of learning, of quiet intent, of whispers and of chance encounters, the library is a space where nothing is said but everything is meant. As Arturo spies Cecilia looking for a book, he undresses her with his gaze before offering to help her find the book she seeks. Reminiscent of Sergio's gaze in *Memorias del subdesarrollo/Memories of Underdevelopment* (Tomás Gutiérrez Alea, 1968) as he spies a woman in a bookshop, it is the look that fascinates in Hamlet's film. Visually provocative and morally disquieting, the film exposes some of the sexual secrets behind the quiet facade of a troubled city in which economic adversity encourages dubious moral behaviour that is hidden behind a cloak of secrecy and whispers. The sensual jazz music as Arturo and Cecilia first set eyes on each other stands in for the words that cannot be spoken, the library synecdochically representing the city that holds a million secrets between lovers, where prostitution, homosexuality and bisexuality are not on shelves for public browsing but can be found quite easily with the correct reference card. **+Guy Baron**

Photo © Rodolfo Rubio Guarde (Panoramio)

Directed by Léster Hamlet
Scene description: Arturo first meets Cecilia in the library
Timecode for scene: 0:2:27 – 0:4:20

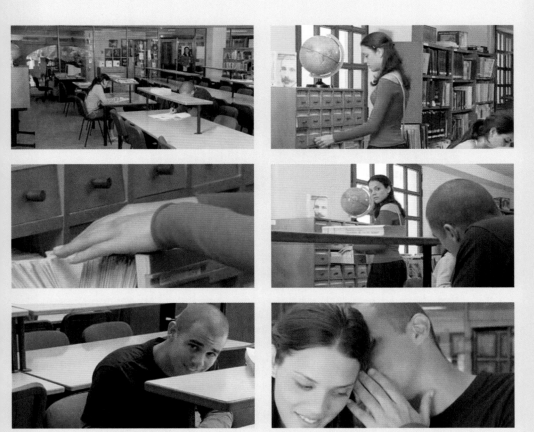

JUAN OF THE DEAD/
JUAN DE LOS MUERTOS (2011)

Revolution Square

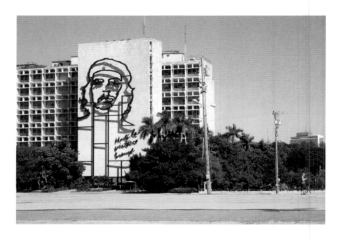

CUBA'S FIRST ZOMBIE FILM was an instant hit. In this delightful feature, iconic Havana locales are employed to new ends or replaced altogether: the parking garage under the Hotel Habana Libre (Havana Hilton in pre-revolutionary times) serves as the bunker where the zombie hunters regroup, the rooftop overlooking G Street between 23rd and 25th Avenues introduces new city views, and several residential streets in the Vedado district make their screen debut. In some cases, iconic locales are reconfigured as sites of conflict and upheaval: as Juan and Lázaro observe the FOCSA building, noting their displeasure with the way the long-time Soviet residential high-rise blocks the sun, the tall complex implodes; the cupola of El Capitolio, struck by an out-of-control aeroplane, goes up in flames. The events occurring in the Plaza de la Revolución are perhaps the most unexpected. This expansive square, home to monuments honouring heroes José Martí and Ché Guevara, and flanked by the Presidential Palace, National Library and Ministry of the Interior, often attracts massive crowds. It was here that Fidel Castro gave his legendary speeches, where Popes John Paul and Benedict celebrated Catholic mass, and where renowned musicians (Silvio Rodríguez, Orishas, Juanes) performed. In *Juan of the Dead* this square hosts something quite different – a cleverly choreographed zombie massacre. The function of this urban space is reconfigured yet again. *Juan* impresses and entertains in great part because it manages at once to be recognizable and different; it adheres to conventions characterizing the genre while contributing a distinctive 'Cuban' flavour.
↦ Ann Marie Stock

Photo © Ann Marie Stock

Directed by Alejandro Brugués
Scene description: A zombie blood bath in Havana's huge civic plaza, Revolution Square
Timecode for scene: 1:08:19 – 1:10:36

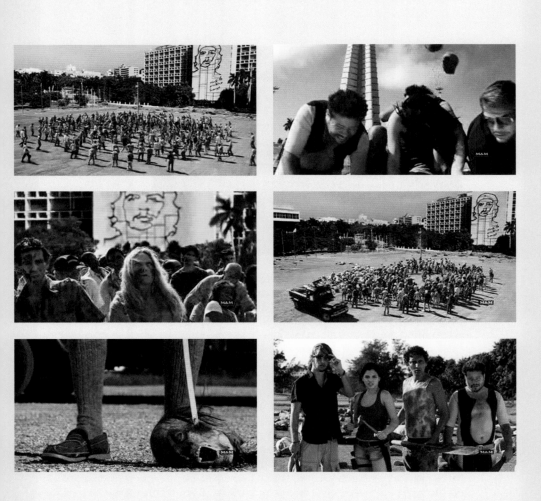

THE MOLE'S HIDEOUT/
LA GUARIDA DEL TOPO (2011)

2610 35th Street between 30th and 26th, Playa

SOME FILM LOCALES draw attention because of their iconic appeal. Others, however, resonate because of an off-screen event. This is the case with *The Mole's Hideout*. Principal filming took place in a residential neighbourhood in Playa. Alfredo Ureta and team had rented a house on a street lined with single-family dwellings, many fronted by porches and yards. There they set up equipment and worked to create an intimate portrait of Daniel (Néstor Jiménez). With cameras rolling – in the bathroom, kitchen and bedroom – they depicted the solitary life of this 'mole'. The recluse's routine is interrupted when his neighbour's daughter seeks refuge from her abusive husband, and hides out with Daniel. Enclosed together in the same space, the two lonely individuals find solace in one another and begin to share ever-more intimate moments. What results is a film of 'interiors', a work that probes the psychology of individuals. When the filming phase of the project was complete, the proprietors urged Ureta and his *compañera*, the producer Susel Ochoa, to stay on. Such was the friendship developed during the course of the filming that the couple remained living in the home until several months later, after the birth of their first child. **•►Ann Marie Stock**

Photo © Troy Davis

Directed by Alfredo Ureta
Scene description: Ana hides out with Daniel in his home
Timecode for scene: 1:25:20 – 1:28:05

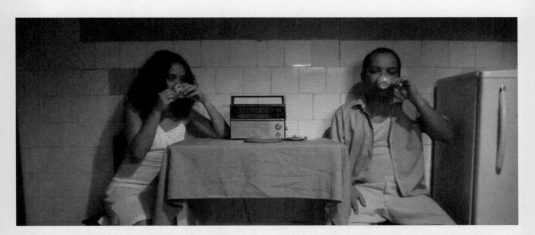

UNFINISHED SPACES (2011)

National Art Schools

'**THERE WERE MANY YEARS** that no one mentioned the Schools ... [they] were practically forgotten.' With this inaugural pronouncement by architect Roberto Gottardi, memory and oblivion become the lens through which Cuba's National Art Schools are presented. Constructed in the early 1960s, the Schools embodied student freedom and liberated artistic expression; they typified the exuberant spirit of the 1959 Revolution. Over time, however, the Schools and their innovative architecture threatened Cuba's new revolutionary order. Construction was halted; the architects dispersed. The Schools' subsequent history parallels the ebb and flow of revolution in Cuba, and *Unfinished Spaces* explores this chronology. The film opens with Fidel Castro's victory parade in January 1959. As the nation forged its socialist future, a few bastions of Cuba's imperialist past endured, namely Havana's Country Club Park, a popular retreat for *Habanero* elite and wealthy American visitors. One sunny day in March 1959, Castro and Ché Guevara visited the Club for a game of golf. Amidst the grumblings of horrified Havana aristocrats, Fidel uttered a fantastic idea: 'Imagine if we could put hundreds of students of art in this magnificent landscape!' With the final swing of his club, fantasy became reality. Two months later, architects Ricardo Porro, Vitorrio Garatti and Roberto Gottardi had designed five sprawling, modern configurations devoted to Modern Dance, Plastic Arts, Ballet, Music and Drama. Architecturally, the Schools were like nothing else in Havana. They were modern, elegant and fluid. Soon, however, their innovative architecture would be deemed counter-revolutionary. Funding disappeared and construction ceased in July 1965. For the next 43 years, the buildings fell into disrepair, becoming entangled in webs of weeds and ivy. Early in the twenty-first century, the Cuban government began repairing the unfinished structures. By tracing this cycle, *Unfinished Spaces* reminds viewers that, though physically incomplete, Cuba's National Art Schools will forever occupy a very full, very robust space within Cuba's artistic and social landscapes. ⊷**Emma Rodvien**

Photo © Google Earth

Directed by Alysa Nahmias and Benjamin Murray
Scene description: Fidel and Ché play golf at Havana's Country Club Park, future location of the National Art Schools
Timecode for scene: 0:01:45 – 0:03:51

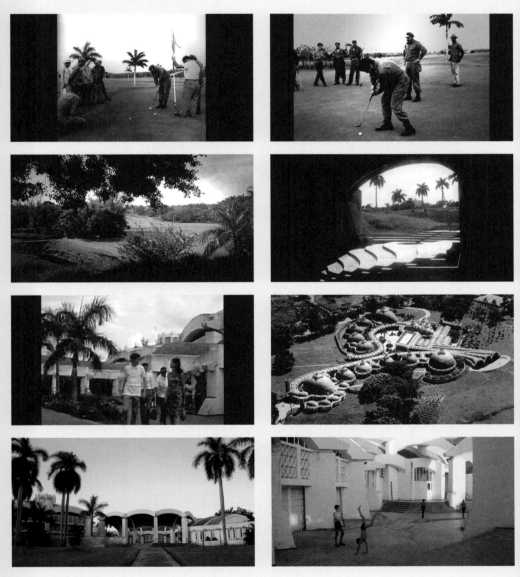

7 DAYS IN HAVANA /
7 DÍAS EN LA HABANA (2012)

National Capitol Building (El Capitolio)

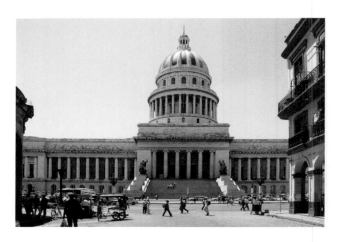

'**A CONTEMPORARY PORTRAIT** of this eclectic city through a single feature-length movie made of seven chapters, directed by seven internationally acclaimed directors.' So announces the film, establishing a global context for its portrayal of Havana. Nowhere is this globalized vision of the city more present than in the film's opening chapter, 'El Yuma'. The storyline follows Teddy, an American student, and Angelito, an ebullient Cuban taxi driver who guides Teddy through the city. We hear the two bond over stories of international travel, exchanging memories of time spent abroad and tales of foreign adventures. In one instance, Angelito mumbles a few words in Russian, remnants of his time in the Soviet Union. This spirit of global interchange accompanies Angelito and Teddy as they drive past the Capitolio building. In an attempt to identify with his American passenger, Angelito points out the architectural similarities between the Capitolio and its American counterpart. He proudly informs Teddy, 'It's an exact replica of your Capitol, but it is 5 cm taller than the one in Washington, DC.' Teddy, surprised by the resemblance and amused by the precision of Angelito's measurement, chuckles, '5 cm? That's like 2 inches.' At times worlds apart, the American and Cuban capitols now appear separated by a mere 2 inches. Teddy stares thoughtfully out of his window, trying to make sense of the sweeping similarities and miniscule differences between Havana and his own home. By blending local and external perspectives, *7 Days* reminds viewers that Havana – from its taxi drivers to its buildings – is in dialogue with the world. **⮞ Emma Rodvien**

Directed by Benicio del Toro, Pablo Trapero, Julio Médem, Elia Suleiman, Gaspar Noé,
Juan Carlos Tabio and Laruent Cantet
Scene description: Angelito and Teddy drive by the Capitolio building
Timecode for scene: 0:05:22 – 0:06:21

 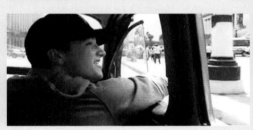

ANA'S MOVIE/LA PELÍCULA DE ANA (2012)

LOCATION *Zanja 4-48 between Galiano and Águila, Centro Habana*

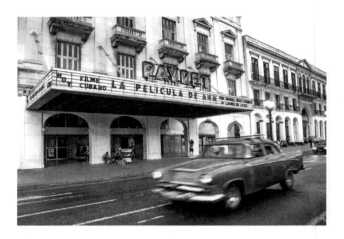

ANA'S MOVIE joins the list of films that recall Cuba's Special Period and the clever ways Cubans had to improvise to cope with its effects. 'Inspired by real events', the plot follows a frustrated actress Ana (Laura de la Uz) who is obsessed with getting $500 to buy a refrigerator for her family, an opportunity she discovers after meeting Flavia (Yuliet Cruz). Through Flavia, Ana is introduced to Austrian film-makers interested in depicting the life of a modern Cuban prostitute (*jinetera*). The scene unfolds on a rooftop in the heart of the Centro Havana neighbourhood. Dressed in red, wearing a wig and dark glasses, Ana – finally an actress – draws upon her histrionic genius to narrate her (invented) life during the hard years, including how she had to prostitute herself in order to survive. In the background, the camera captures the cupola of the Capitolio, and a rare, angled shot of the majestic Empresa de Teléfonos, which was Havana's tallest structure when it was built in 1927. It changes position and focuses on the ruins of a once remarkable structure, reflecting a similar change in Ana, who can no longer avoid remembering her real drama. Impressed by her compelling and unusual 'evocative acting', the Austrians return to direct a film that delves into Ana's daily life. With encouragement from Flavia and Ana's own husband (Tomás Cao), the trio paints a tale with sympathetic, and at times dramatic, brushstrokes of life in 1990s Cuba.
⇥Pablo Fornet

Photo © Kathy Hornsby

Directed by Daniel Díaz Torres
Scene description: Ana on a rooftop, dressed like a jinetera, tells her story to the camera
Timecode for scene: 0:25:53 – 0:30:48

ESTHER SOMEWHERE/ ESTHER EN ALGUNA PARTE (2013)

Lino and Maruja's bedroom, 955 13th Street between 8 and 10, Vedado

SOMETIMES LOCATIONS STAND OUT for their simplicity and un-remarkability. In Esther Somewhere one such location speaks volumes for the depth and subtlety of its vision. As Lino (Reynaldo Miravailles) contemplates some old photographs of his recently deceased wife Maruja (Daisy Granados), he sits on their marital bed, a photograph of her hanging on the wall behind his head. Unremarkable until you consider that the photograph is that of the character Teresa (also played by Granados), taken by her husband in the 1979 film *Retrato de Teresa/Portrait of Teresa* by Pastor Vega. The photo presents a portrait of Teresa, with hair swept across her face in a highly charged, sensual image. In the 1979 film Teresa leaves her husband to find an independent life for herself, but we never discover whether or not she has had an affair. Her sexual agency remains firmly tucked under the bedclothes of a 1970s Cuba that would not have accepted female extra-marital sexual activity, even on the big screen. But in Esther, Lino discovers that his wife had led a double life; she was a nightclub singer and had several lesbian affairs. The connection then between the marital bedroom, realm of so many secrets, troubles and marriage difficulties, the nostalgic repetition of one of Cuban cinema's most iconic (and sexually charged) images and the sexual secrets tied up in the life of Maruja, give this location a resonance beyond the simplistic humble setting.
⇨ *Guy Baron*

Directed by Gerardo Chijona
Scene description: Lino learns the truth about his former wife
Timecode for scene: 0:59:18 – 1:00:26

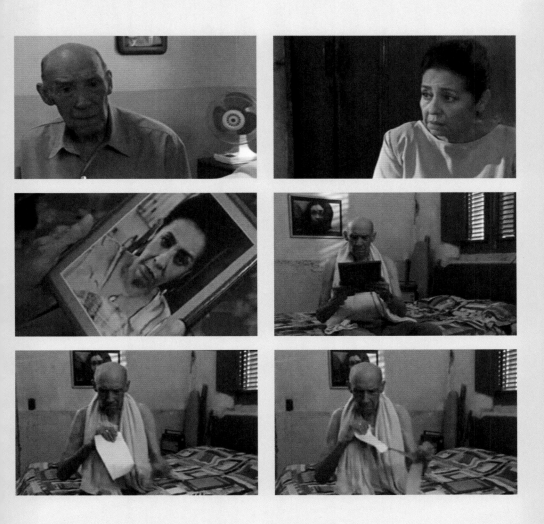

GO FURTHER

Recommended reading, useful websites and film availability

BOOKS AND ARTICLES

On Location in Cuba: Street Filmmaking during Times of Transition
by Ann Marie Stock
(University of North Carolina Press, 2009)

Bridging Enigma: Cubans on Cuba
by Ambrosio Fornet
(The South Atlantic Quarterly, Vol. 96, No. 1,
Winter 1997)

Abrí la Verja de Hierro/ I Opened the Iron Gate
by Fayad Jamis
(Union de Escritores y Artistas Cubanos, 1973)

Place, Power, Situation and Spectacle. A Geography of Film
by Stuart C. Aitken and Leo E. Zonn
(Rowman and Littlefield, 1994)

'Nation, Cinema and Women: Discourses, Realities and Cuban Utopia'
by J. B. Alvarez
(Global Development Studies, Vol. 1, No. 3-4, 1998)

Cuban Cinema
by Michael Chanan
(University of Minnesota Press, 2004)

Gender in Cuban Cinema
by Guy Baron
(Peter Lang, 2011)

Los Cien caminos del cine cubano/One Hundred Paths of Cuban Film
by Marta Díaz and Joel del Río
(Ediciones ICAIC, 2010)

Guía crítica del cine Cubano de ficción/Critical Guide to Cuban Fiction Films
by Juan Antonio García Borrero
(Editorial Arte y Literatura, 2001)

Cine y revolución cubana: luces y sombras/Cinema and Revolution in Cuba: Lights and Shadows
ed. by Nancy Berthier
(Archivos de la Filmoteca 59, 2008)

ONLINE

Instituto Cubano de Arte e Industria Cinematográficos (Cuban Film Institute)
http://www.cubacine.cult.cu

Fundación del Nuevo Cine Latinoamericano (New Latin American Cinema Foundation)
http://www.cinelatinoamericano.org/fncl.aspx?cod=1

Escuela Internacional de Cine y TV (International School of Cinema and Television)
http://www.eictv.org/en

Festival Internacional del Nuevo Cine Latinoamericano (International Festival of New Latin American Cinema)
http://www.habanafilmfestival.com

Cine Cubano: La Pupila Insomne (Cuban Cinema: The Insomniac Pupil) – blog
http://cinecubanolapupilainsomne.wordpress.com/author/virgen1964/

Havana Cultura – profiles of Cuban film-makers
http://www.havana-cultura.com/en/int/cuban-artists

Cuban Film Institute (ICAIC) – distributor of feature films, documentaries and animation
http://www.cubacine.cult.cu/sitios/productoraICAIC/english/catalogo.php

Cuban Cinema Classics – distributor of documentaries and interviews with Cuban film-makers subtitled in English
http://www.cubancinemaclassics.org/Cuban_Cinema_Classics.html

Icarus Films – distributor of Cuban films
http://www.icarusfilms.com

➜

CONTRIBUTORS

Editor and contributing writer biographies

EDITOR

ANN MARIE STOCK is Director of the Film and Media Studies programme at the College of William and Mary. A specialist on Cuban film and new media, she is the author of *On Location in Cuba: Street Filmmaking during Times of Transition* (University of North Carolina Press, 2009) and more than 100 essays and book chapters. Dr Stock is the founding director of Cuban Cinema Classics (www.cubancinemaclassics.org), a non-profit initiative disseminating Cuban documentaries with English subtitles, and editor of *Framing Latin American Cinema: Contemporary Critical Perspectives* (1997). She regularly curates film programmes and serves on festival juries around the world.

CONTRIBUTORS

GUY BARON is Lecturer in Spanish and Latin American Studies at Aberystwyth University, UK. He is a widely published author on Cuban cinema and his book, *Gender in Cuban Cinema, 1974–1990*, was published with Peter Lang in 2011. He also publishes regularly in *Revista Cine Cubano*. Dr Baron is the director of the transnational Cuban Cinema Seminar Series sponsored by the British Academy.

M. TROY DAVIS is Director of Media Services in Swem Library at the College of William and Mary. He also teaches a variety of topics, including Remix culture and media practice, in the Film and Media Studies programme. Davis has travelled to Cuba to assist with research on film-making, and served as Cuba location photographer and videographer for several projects.

DÉSIRÉE DÍAZ is a doctoral candidate at the University of Madison-Wisconsin where she specializes in Latin American and Caribbean literatures and visual culture. Her work on Cuban cinema has appeared in a number of edited volumes and journals. She is former editor of Cuban cultural magazine *La Gaceta de Cuba*.

PABLO FORNET is a geographer and has an MA in Urban Studies. For 30 years he has studied and worked on urban heritage preservation, specifically preservation of the Old Havana neighbourhood. He is a professor of urban management at the San Gerónimo College of the University of Havana. In addition, he has authored various essays related to the history of Cuba's capital city.

MIRYORLY GARCÍA PRIETO, Editor of the *Cine Cubano* journal, has an MA in Art History from the University of Havana. For more than a decade she has conducted research and written about Cuban audio-visual culture. Previously, she was a specialist at the Ernest Hemingway Museum, known as the Finca Vigía. She is the author of *El mito Hemingway en el audiovisual cubano/The Hemingway Myth in Cuban Audiovisual Culture* (Ediciones ICAIC, 2011).

KATHY HORNSBY is an enthusiastic photographer and artist, finding boundless inspiration from travels to unfamiliar locales and cultures. A favourite area of photographic interest is environmental portraiture, capturing the lives of people in their particular and often unique environments. After graduating from the College of William and Mary, Kathy's careers included teaching and graphic design. She is a longtime advocate for the arts and public education.

→

CONTRIBUTORS

Editor and contributing writer biographies (continued)

SUSAN LORD teaches in the Department of Film and Media at Queen's University in Kingston (Canada). Her research focuses on urban screens and gendered projections of postcolonial worlds. She has written about Cuban cinema and is currently completing two projects: a collection of essays *Images of Utopia, Documents of Belonging: Sara Gomez's Contribution to Cuban and World Cinema*; and *Decolonized Cosmopolitanism: The Visual Culture of Havana from 1959 to 1968*, an archival collaborative project grounded in the visual culture of Havana during its most open period as a decolonized cosmopolitan centre.

MARIO NAITO LÓPEZ has been active in film programming and criticism in Cuba for more than four decades. He has contributed to a variety of print publications including *Granma* and *El Mundo*, *Arte Siete* and *Revolución y Cultura*. In 1993 he founded the Cuban Association of Cinematographic Press, over which he has presided since 2006. Mr López prepared *Coordinadas del Cine Cubano 2* (Editorial Oriente, 2005) and edits material for the *Cinemateca de Cuba*, where he has worked as a film specialist since 2002. He has also authored over 500 entries for the *Dictionary of Iberoamerican Cinema* (Madrid, 2011).

ANTONIO A. PITALUGA, Professor of History and Theory of Cuban Culture at the University of Havana, is the author of *Revolución, hegemonía y poder* (Havana, 2012). Dr Pitaluga has lectured and taught in Costa Rica, Venezuela, Italy and the United Kingdom, and served as a post-doctoral fellow at the University of Bologna (Italy). He currently co-directs the 'Cuban Film Today and Tomorrow' initiative supported by the British Academy.

LAURA PODALSKY teaches Latin American film and cultural studies at the Ohio State University. She has published essays on a wide variety of topics, including pre-revolutionary Cuban cinema. She is the author of *Specular City: Transforming Culture, Consumption, and Space in Buenos Aires, 1955–1973* (Temple University Press, 2004) on Argentine film and urban culture, and *The Politics of Affect and Emotion in the Contemporary Latin American Cinema: Argentina, Brazil, Cuba and Mexico* (Palgrave Macmillan, 2011).

RICHARD REITSMA is Assistant Professor of Spanish/Latin American Studies at Canisius College in Buffalo, New York. Dr Reitsma is currently working on gender and minority representation in Latino/Latin American/Caribbean literature and film. Recent works include 'Queer (In)Tolerance in Children's Animated Film', 'Quo Vadis queer vato? Queer and Loathing in L.A.' and 'Lethal Latin Lovers: Homo-Sex and Death in Latin American Cinema'.

EMMA RODVIEN is an undergraduate student of Latin American Studies at the College of William and Mary. She has conducted research in Cuba on music, participated in subtitling Cuban documentaries into English for the Cuban Cinema Classics initiative, and served as Research Assistant for this volume. In addition to authoring four scene descriptions and creating the map she assisted in translating text, capturing and selecting screen shots, and preparing the manuscript for submission.

Rob Stone is Professor of Film Studies at
the University of Birmingham in the UK, where
he directs B-Film: The Birmingham Centre for
Film Studies. He has published widely on Cuban,
Spanish and Basque cinema; Surrealism; and
independent American cinema. His books include
Spanish Cinema (Longman, 2002), *Julio Medem*
(Manchester University Press, 2007) and *The
Cinema of Richard Linklater: Walk, Don't Run*
(Columbia University Press, 2013). His co-written
Basque Cinema: A Cultural and Political History
will be published by IB Tauris in 2015.

Fabienne Viala is Assistant Professor in
Hispanic Studies at the University of Warwick,
UK. She has published comparative studies on
the historical novel, national memory and crime
fiction in Hispanic and Francophone literatures,
including the books: *Marguerite Yourcenar, Alejo
Carpentier: Ecritures de l'histoire* (Peter Lang, 2008);
*Le roman noir à l'encre de l'histoire: Manuel Vázquez
Montalbán et Didier Daeninckx* (L'Harmattan,
2006); *Le roman noir au paradis perdu: le néo-
polar cubain de Leonardo Padura* (L'Harmattan,
2007); and *Alejo Carpentier, Pintando la Historia :
Narrativa histórica, narrativa icnográfica* (Tizona,
2006).

Carl Wilson is Associate Lecturer in Film,
Television and Media at Sheffield College in
the UK. His writing has recently appeared in
*PopMatters, Film International, The Essential
Sopranos Reader* (University Press of Kentucky,
2011), and *Directory of World Cinema: American
Independent* (University of Chicago Press, 2010)
and *Directory of World Cinema: American
Hollywood* (2011). He has work forthcoming in
other Directory of World Cinema titles, and *World
Film Locations: Vancouver* (Intellect, 2013).

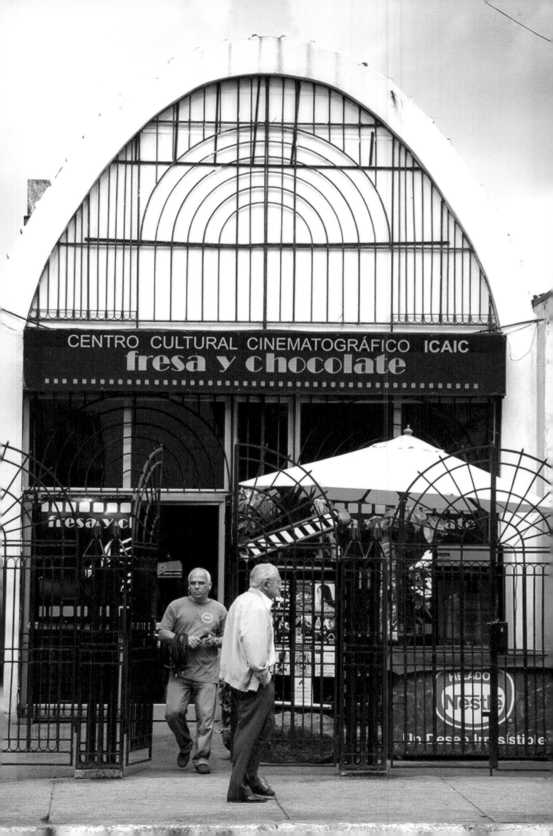

FILMOGRAPHY

All films mentioned or featured in this book

Film	Pages
7 Days in Havana/7 Días en La Habana (2012)	2,103,112
Ana's Movie/La película de Ana (2012)	7,103,114
Awkward Age, The/La Edad de la peseta (2006)	6,85,90
Bad Boys 2 (2003)	43
Before Night Falls/Antes que anochezca (2001)	7,43,65,70
Belle of the Alhambra Theatre, The/ La Bella del Alhambra (1989)	45,50
Between Hurricanes/Entre ciclones (2003)	22
Buena Vista Social Club (1998)	4,6,65,68
Chico & Rita (2010)	2,6,85,98
Cuba (1979)	42
Cuba Dances/Cuba Baila (1960)	7,25,26
Close Up (2008)	9
Coffea Arábiga (1968)	83
Death of a Bureaucrat/ La Muerte de un burócrata (1966)	7,8,9,25,32
Die another Day (2002)	43,65,74
Dirty Dancing: Havana Nights (2004)	42,65,80
Esther Somewhere/Esther en alguna parte (2012)	7,103,116
Fable/Fábula (2011)	103,104
For the First Time/Por primera vez (1967)	23
Five Obstructions, The/De fem benspænd (2003)	65,76
G Street/Calle G (2003)	9
Gaze, The/La Mirada (2011)	7
General Assembly/Asamblea general (1960)	82
Godfather: Part II, The (1974)	7,25,38,42,43
Good Shepherd, The (2006)	43
Guanabacoa: Chronicle of My Family/ Guanabacoa: Cronica de mi familia (1966)	83
Havana (1990)	42,45,54
Havana Blues/Habana Blues (2005)	6,85,86
Havana Dawns/ Habanaceres (2001)	101
Havana Suite/Suite Habana (2003)	6,40,65,78
Havana Tenement/Solar Habanero (1962)	83
Havana Widows (1933)	7,11,14
Hello Hemingway (1990)	6,45,56
Histories of the Revolution/ Historias de la Revolución (1960)	82
History of Piracy/ Historia de la piratería (1962)	83
Honey for Oshun/Miel para Oshun (2001)	7,65,72
House for Swap/Se permuta (1983)	45,46
I Am Cuba/Soy Cuba (1964)	7,25,30
In an Old Neighborhood/ En un barrio viejo (1963)	83
It Happened in Havana/Romance del Palmar (1938)	7,11,16
José Martí: The Eye of the Canary/ José Martí: El Ojo del canario (2010)	85,96
Juan of the Dead/Juan de los muertos (2011)	7,9,103,106
The Last Days of the Victim/ Los últimos días de la víctima (1995)	65,66
Life is to Whistle/La vida es silbar (1998)	6,9
Local Power//Poder local (1970)	83
Long Distance/Larga distancia (2010)	7,85,94
Lost City, The (2005)	42
M-5/ Eme-5 (2004)	101
Madagascar (1994)	7,8,45,60
Memories of Underdevelopment/ Memorias del subdesarrollo (1968)	7,8,25,34,82,104
Miami Vice (2006)	43
Mole's Hideout, The/La Guarida del Topo (2011)	7,103,108
Morro Castle, Havana Harbour (1898)	11,12
Ode to the Pineapple/ Oda a la Piña (2008)	6
Old Gringo (1989)	23
Old Square/Plaza Vieja (1962)	83
One Way or Another/De cierta manera (1974)	25,36
Original Sin (2001)	42
Our Man in Havana (1959)	7,11,20
Overtime Hours and Volunteer Work/ Sobre horas extras y trabajo voluntario (1973)	83
Palatino Park/Parque de Palatino (1898)	7
Patriot, The (1928)	62
Perfect Human, The (1967)	76
PM (Pasado Meridiano) (1961)	6,25,28,82
Portrait of Teresa/Retrato de Teresa (1979)	25,40,116
Queen and King/Reina y Rey (1994)	7
Remembering Havana/ Desde La Habana 1969 ¡Recordar! (1969)	83
Reportaje (1966)	83
Revolution/ Revolución (2010)	6
Strawberry and Chocolate/Fresa y chocolate (1993)	7,23,45,58
Supporting Roles/Papeles secundarios (1989)	45,52
Swimming Pool, The/La Piscina (2011)	7
Tenement, The/El Solar (1962)	83
Un chien andalou/An Andalusian Dog (1929)	32
Unfinished Spaces (2011)	6,103,110
Utopía (2004)	101
Viva Cuba (2005)	7,85,88
Vampires in Havana/Vampiros en La Habana (1985)	6,45,48
Wall of Words/Pared de las Palabras (2014)	7
Weekend in Havana (1941)	6,11,18
Wreck of the Battleship Maine (1898)	11,12
Zone of Silence/ Zona de silencio (2007)	101

WORLD FILM LOCATIONS
EXPLORING THE CITY ONSCREEN

PRINT AND EBOOK

PARIS

**Edited by
Marcelline Block**

ISBN 9781841505619
PB £15.50 / $22

BEST SELLER

NEW YORK

**Edited by
Scott Jordan Harris**

ISBN 9781841504827
PB £15.50 / $22

BEST SELLER

LONDON

**Edited by
Neil Mitchell**

ISBN 9781841504841
PB £15.50 / $22

PRINT AND EBOOK

MUMBAI

**Edited by
Helio San Miguel**

ISBN 9781841506326
PB £15.50 / $22

PRINT AND EBOOK

BERLIN

**Edited by
Susan Ingram**

ISBN 9781841506319
PB £15.50 / $22

PRINT AND EBOOK

ISTANBUL

**Edited by
Ozlem Koksal**

ISBN 9781841505671
PB £15.50 / $22

PRINT AND EBOOK

VIENNA

**Edited by
Robert Dassanowsky**

ISBN 9781841505695
PB £15.50 / $22

PRINT AND EBOOK

BEIJING

**Edited by
John Berra and
Liu Yang**

ISBN 9781841506425
PB £15.50 / $22

WORLD
FILM
LOCATIONS
EXPLORING
THE CITY
ONSCREEN

www.intellectbooks.com